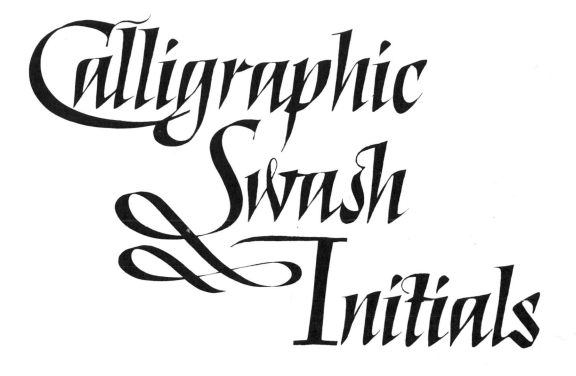

Calligraphic Swash & Initials

Calligraphic Swash & Initials

by **Arthur Baker**

Dover Publications, Inc., New York

Copyright © 1983 by Arthur Baker.
All rights reserved under Pan American and International Copyright
Conventions.

Published in Canada by General Publishing Company, Ltd., 30
Lesmill Road, Don Mills, Toronto, Ontario.
Published in the United Kingdom by Constable and Company, Ltd.,
10 Orange Street, London WC2H 7EG.

Calligraphic Swash Initials is a new work, first published by Dover Pub-
lications, Inc., in 1983.

DOVER *Pictorial Archive* SERIES

Manufactured in the United States of America
Dover Publications, Inc., 180 Varick Street, New York, N.Y. 10014

Library of Congress Cataloging in Publication Data

Baker, Arthur.
 Calligraphic swash initials.

 1. Initials. 2. Calligraphy. 3. Decoration and ornament. I. Title.
NK3640.B22 1983 745.6'197 82-17755
ISBN 0-486-24427-X

Publisher's Note

In the kindred arts of calligraphy and typography, the term "swash" refers to decorative characters with flourishes that are most effectively used as initials, chapter openings, headlines and other display settings. Strictly speaking, the word is applied to special variants of italic typefaces such as Bookman and Caslon with soaring ascenders, sweeping descenders and flowing tails, but its suggestion of dramatically canted display characters makes it a suitable description of the sort of slanting hand lettering showcased in this volume.

Arthur Baker, master calligrapher, type designer and prolific Dover author, has given his imagination free rein to create swash letters that strut like peacocks showing off their gorgeous plumes. This book contains nearly five hundred examples of his exploration of the decorative possibilities of capital letters, illustrating the principle of disciplined freedom in the best sense. Each of the twenty-six letters is treated in at least ten different ways, and some are shown in as many as two dozen variations. The swash characters range in complexity from letters with a single added fillip to forms with ornate scrollwork that practically encloses the central sign in curves whose convolutions repeat and elaborate upon the character's basic structure. Baker's handling of serifs is a study in itself. Here he squares them off; there he makes them swell and loop around. Elsewhere he pens mere wisps in pleasing contrast to the bold strokes of the letter's body.

Baker's talent for combining the best elements of historic hands in novel constructions is readily apparent here. Many of the forms in this versatile collection are adaptations of Chancery cursive majuscules, and so will harmonize beautifully with compositions in that most popular of hand-lettering styles. The more upright letters will work well with modern interpretations of the humanistic hand. There are ornamental features that hark back to other periods—the double cross-bars of many of Baker's swash A's and H's owe a debt to the Versal capitals of the late Middle Ages. Baker pays homage to the Renaissance genius Albrecht Dürer, who used diamond-shaped devices to decorate his famous Gothic alphabet. The modern artist is never content with imitation. Instead, he employs this motif in unexpected ways, occasionally interrupting a vertical stem and turning his pen to another angle before continuing downward, as in the B in the middle of the top row of page 7 and the T in the bottom right position on page 64. Baker often joins two, three or more of these diamonds point to point and arrays them beside a glancing vertical stroke to charming effect.

Calligraphers, typographers and other graphic artists need look no further than this book for ideas and models for their own swash inventions. The letters are large and clearly reproduced, making analysis of the pen manipulation a relatively easy matter. Taken together, these characters are a celebration of the formal properties of letter forms. Individually, they have the power to spark interest in any written message, used judiciously and with good taste.

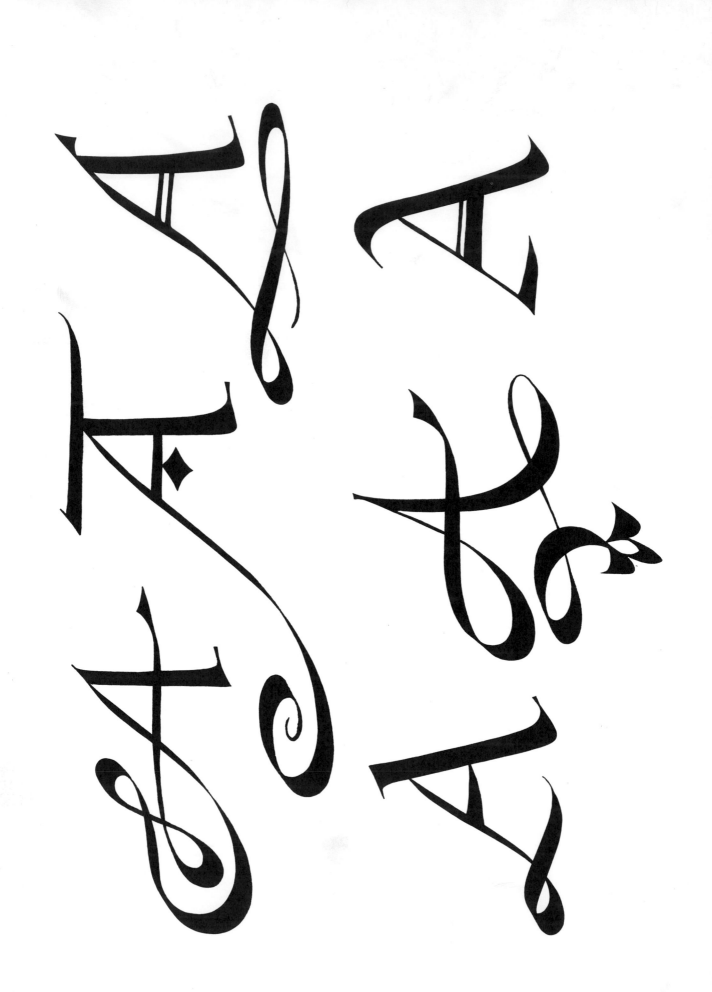

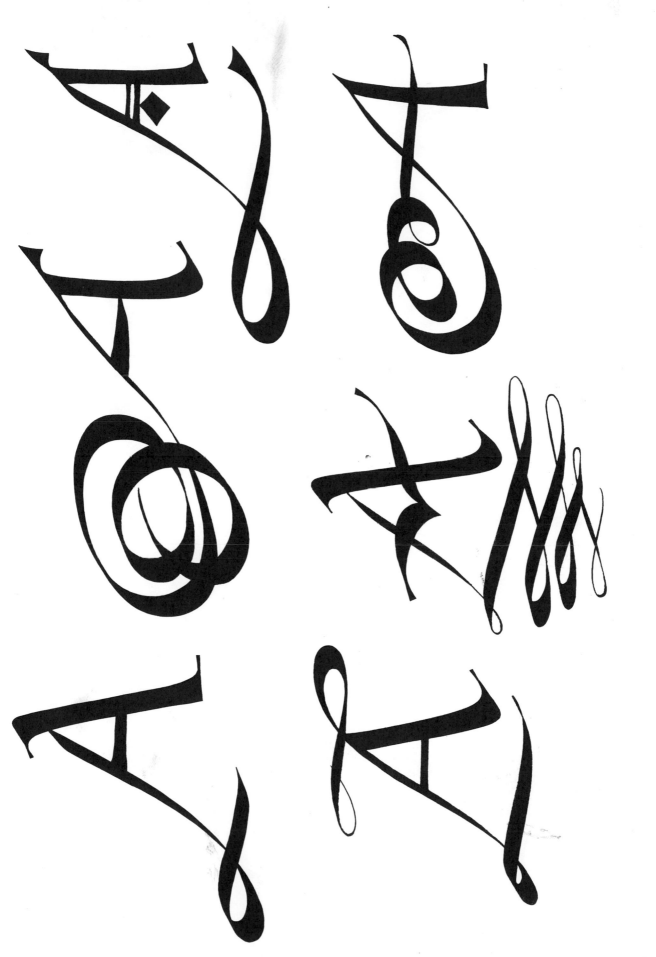

3

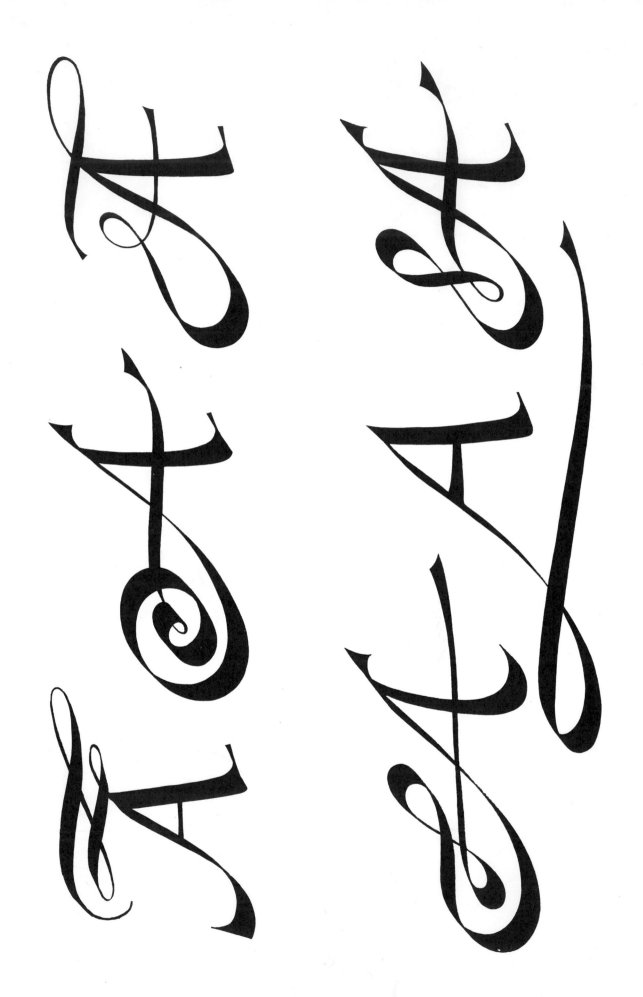

4

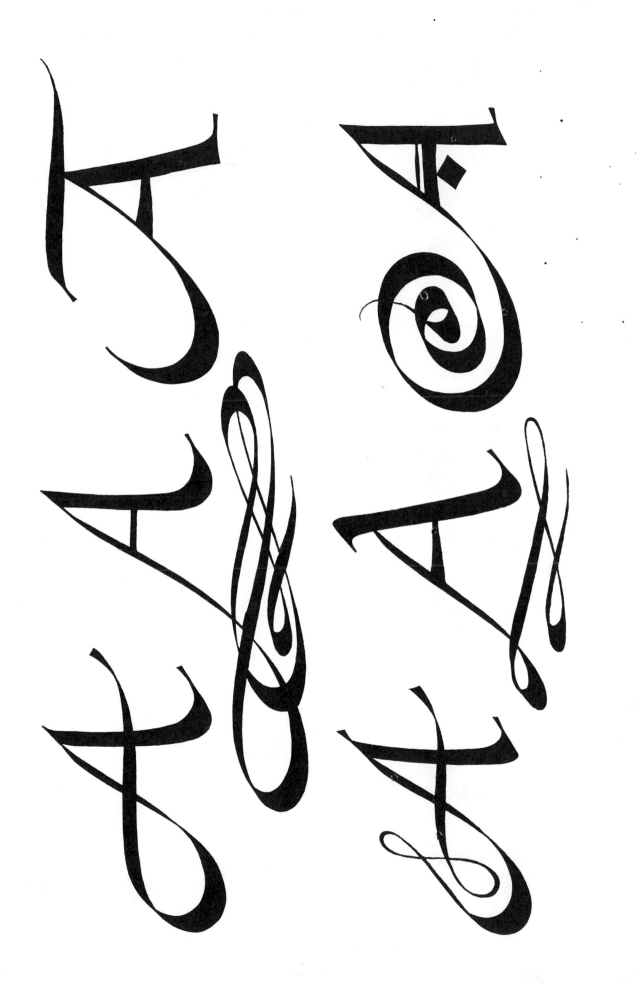

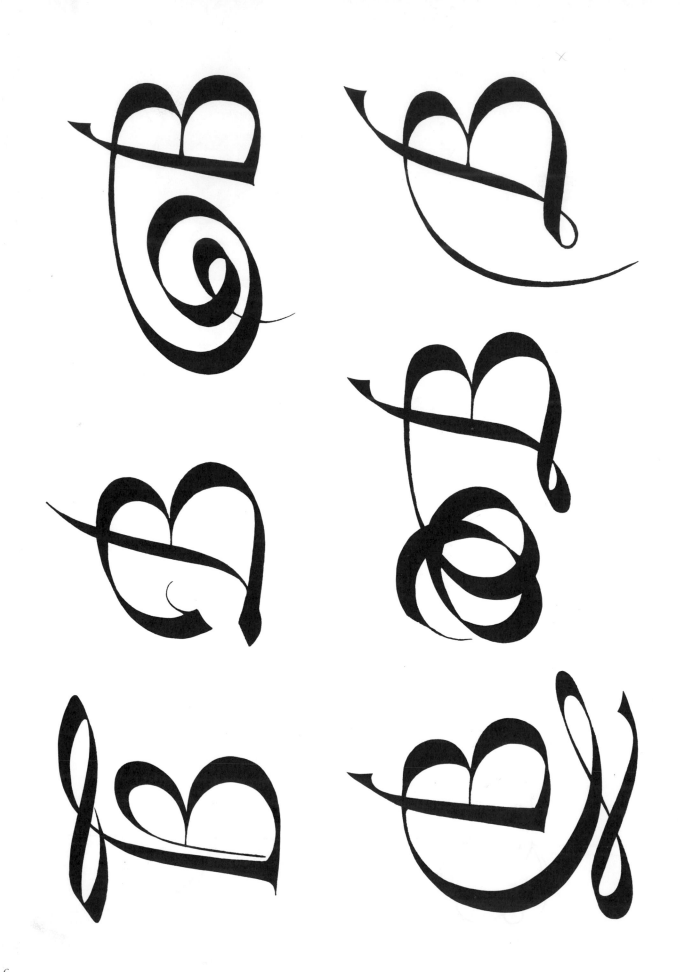

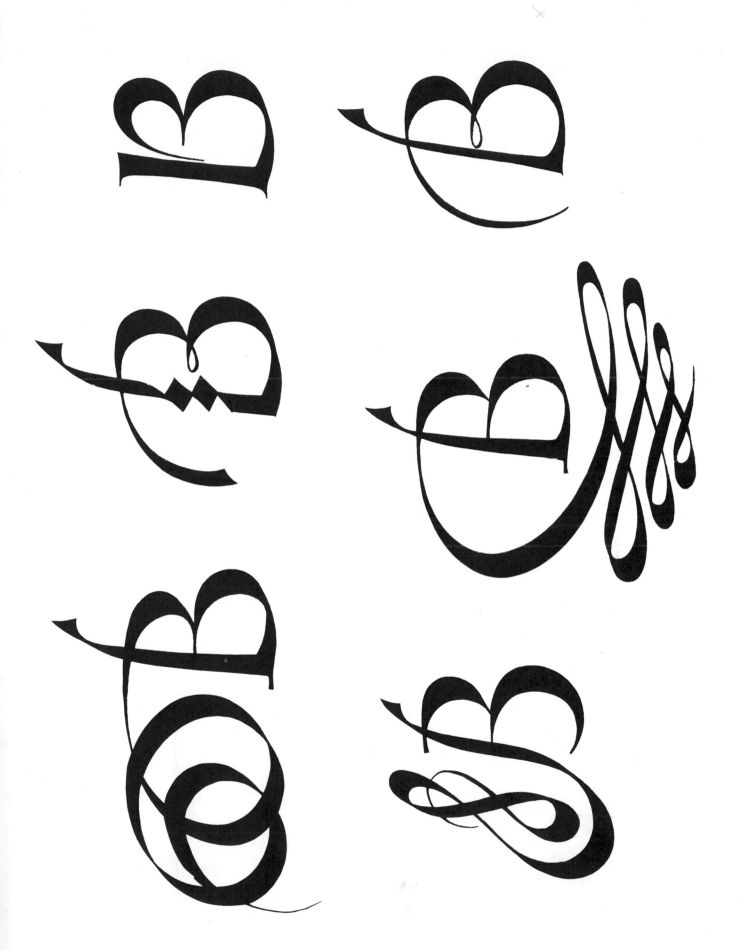

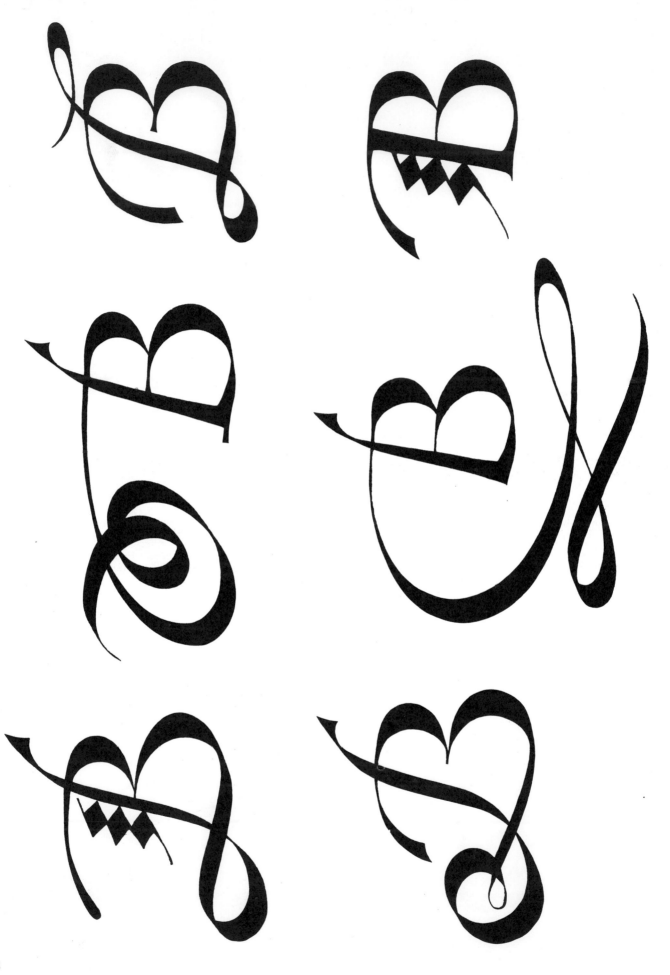

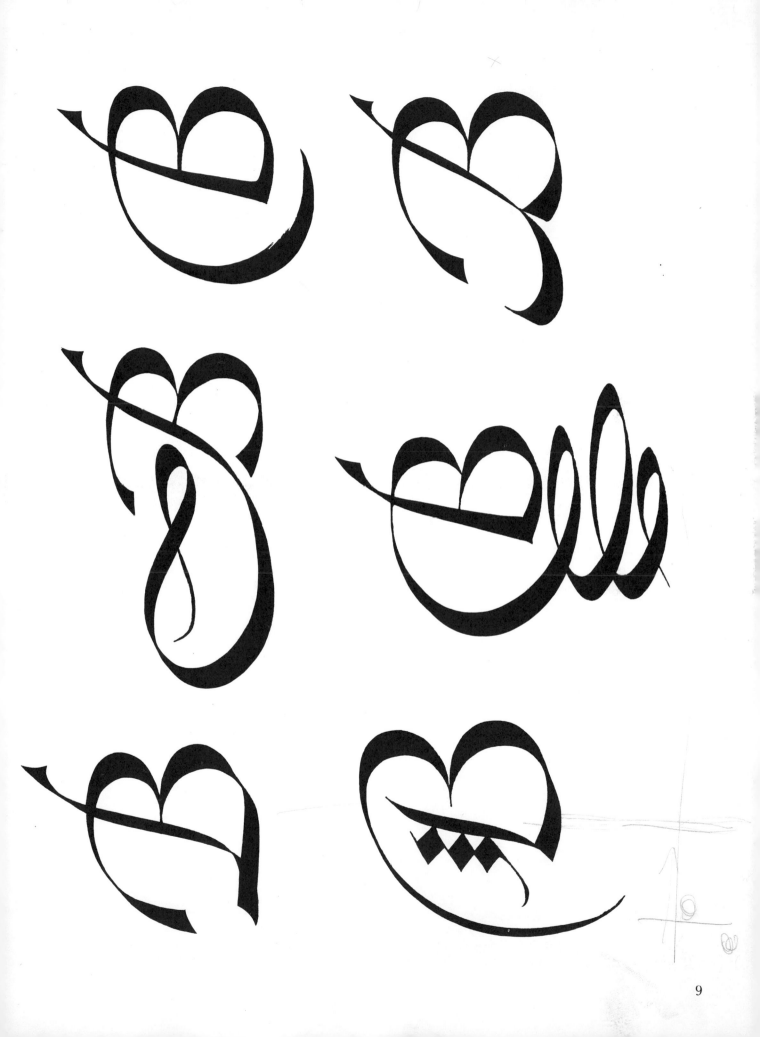

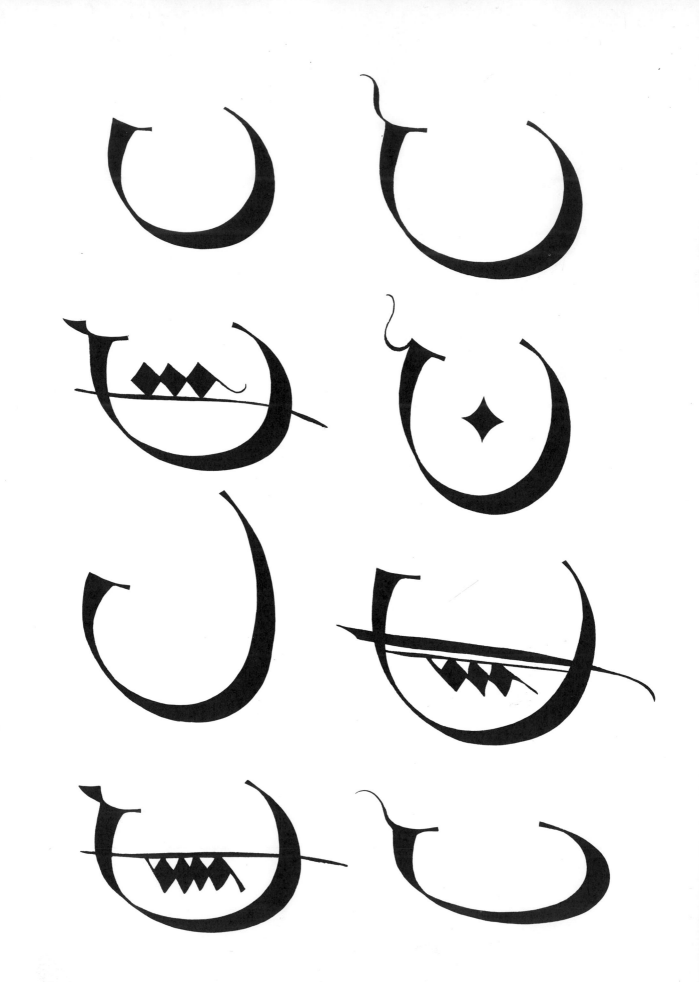

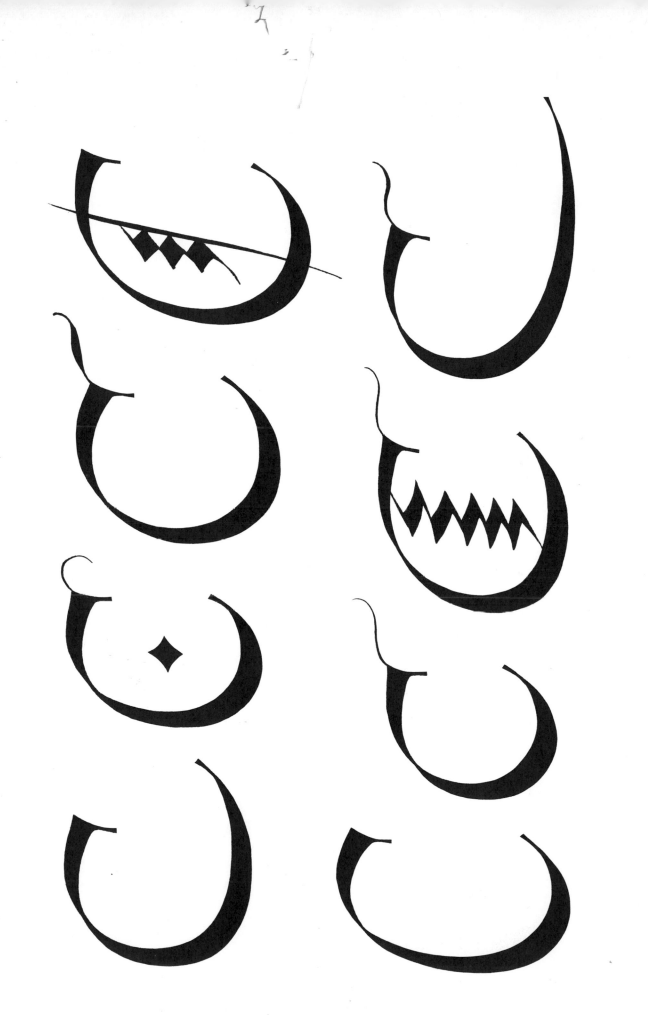

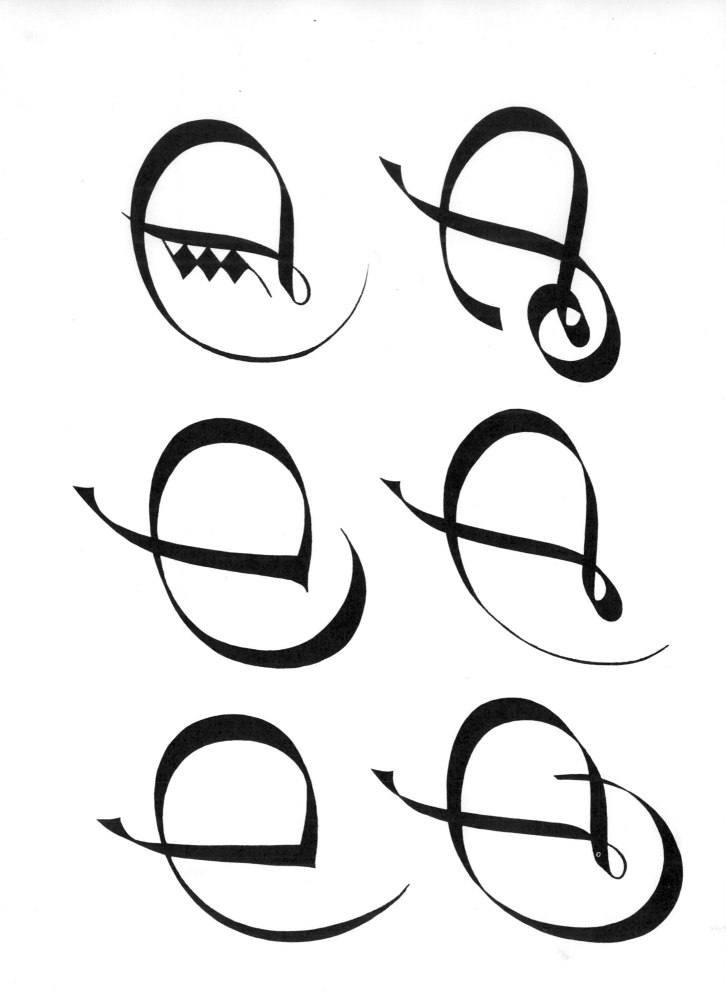

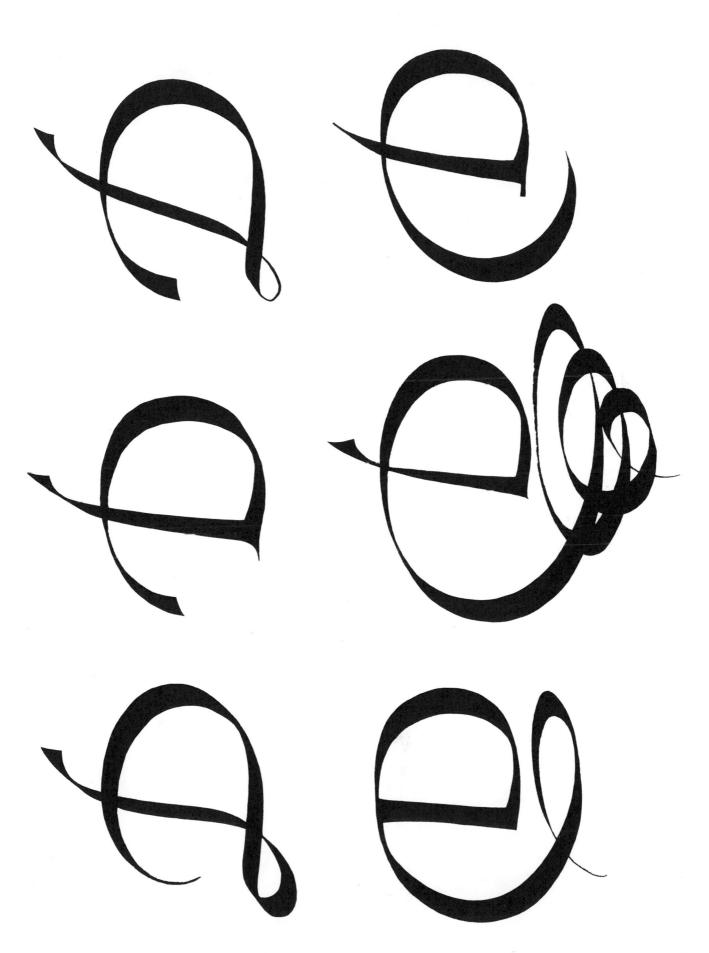

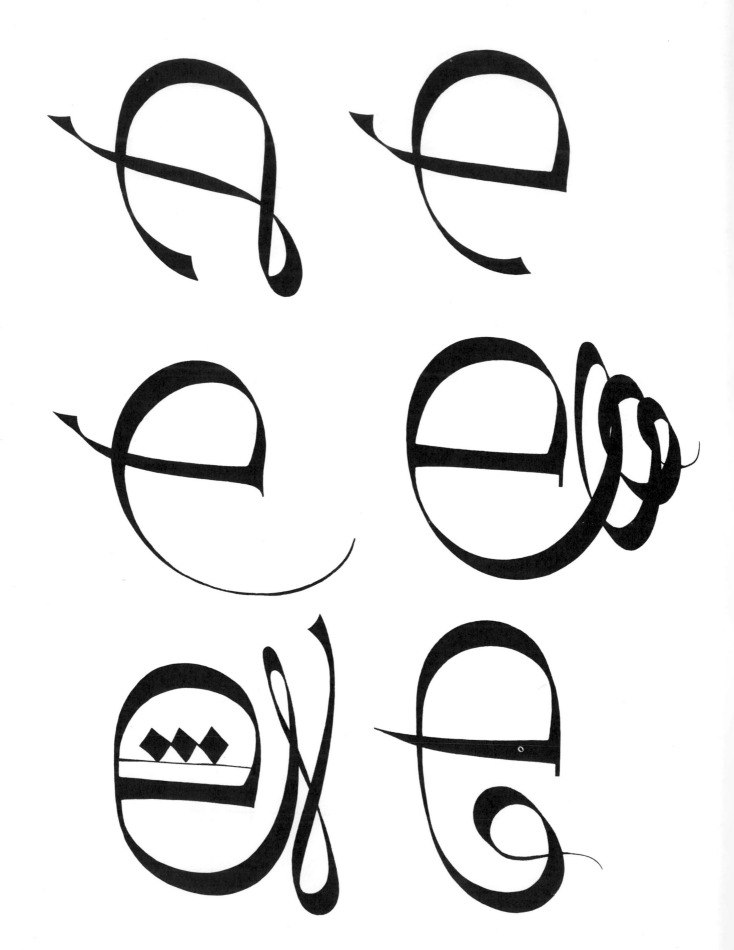

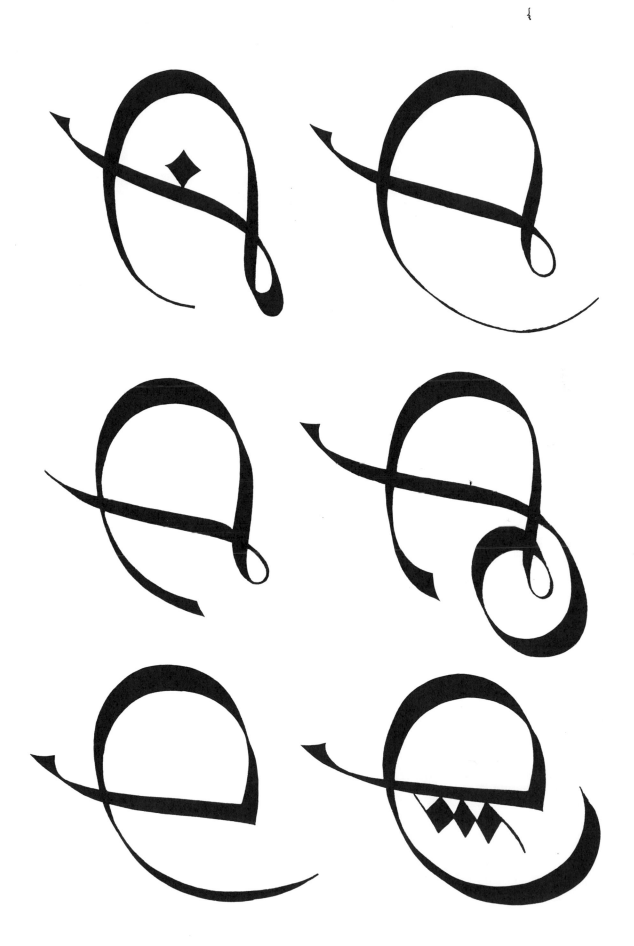

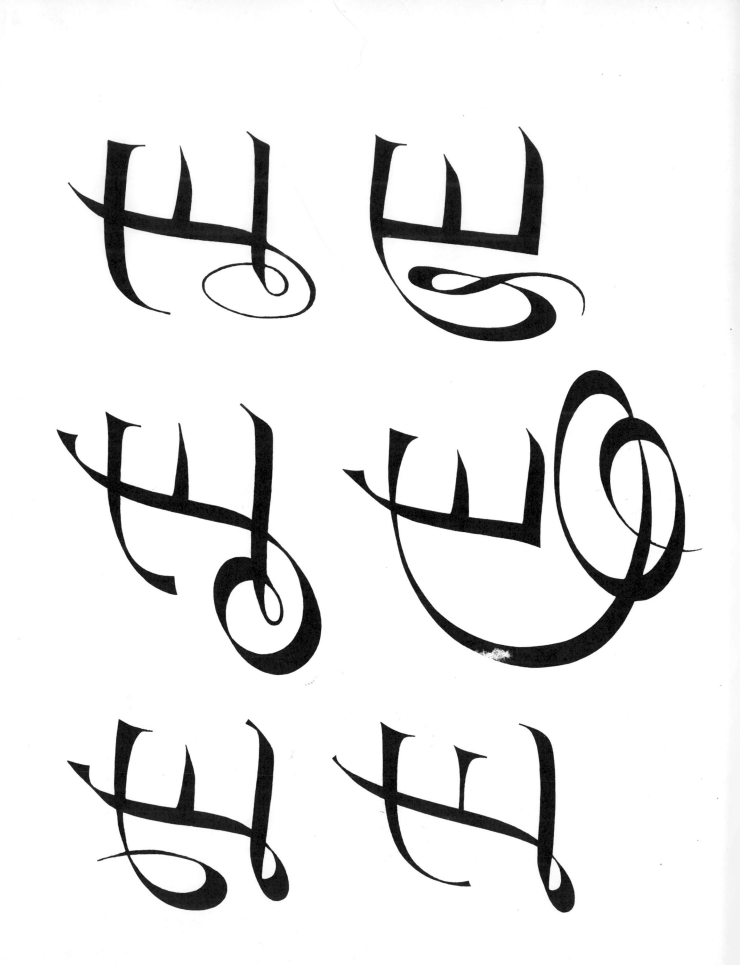

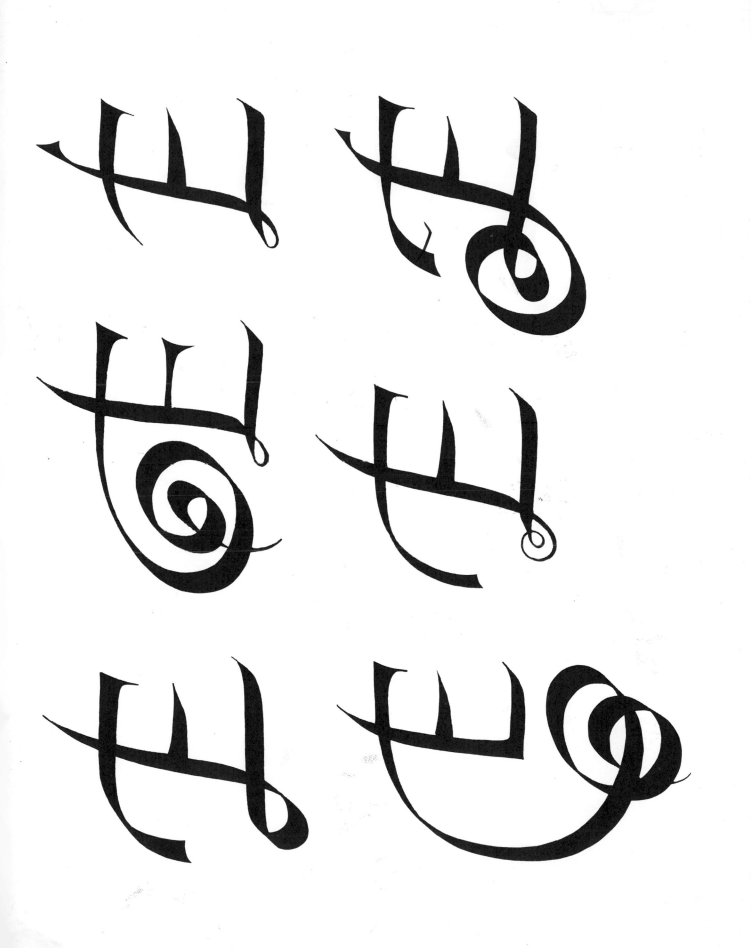

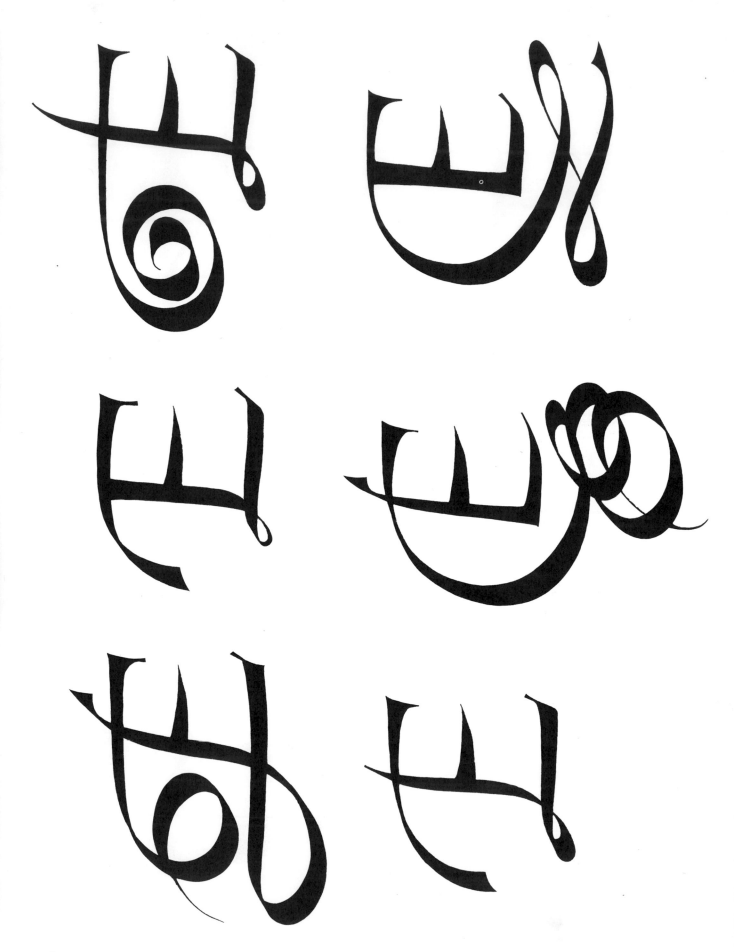

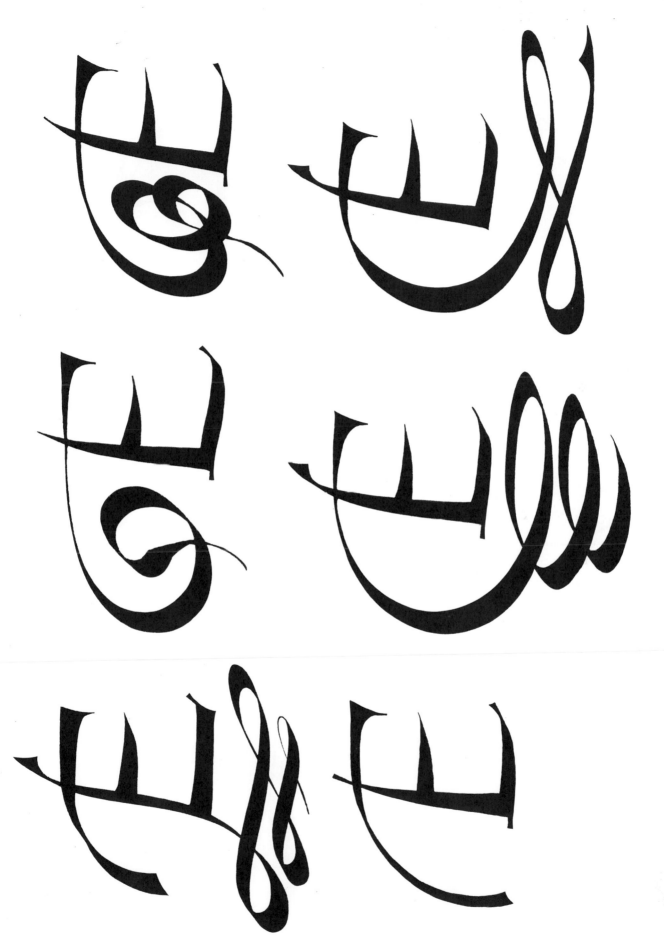

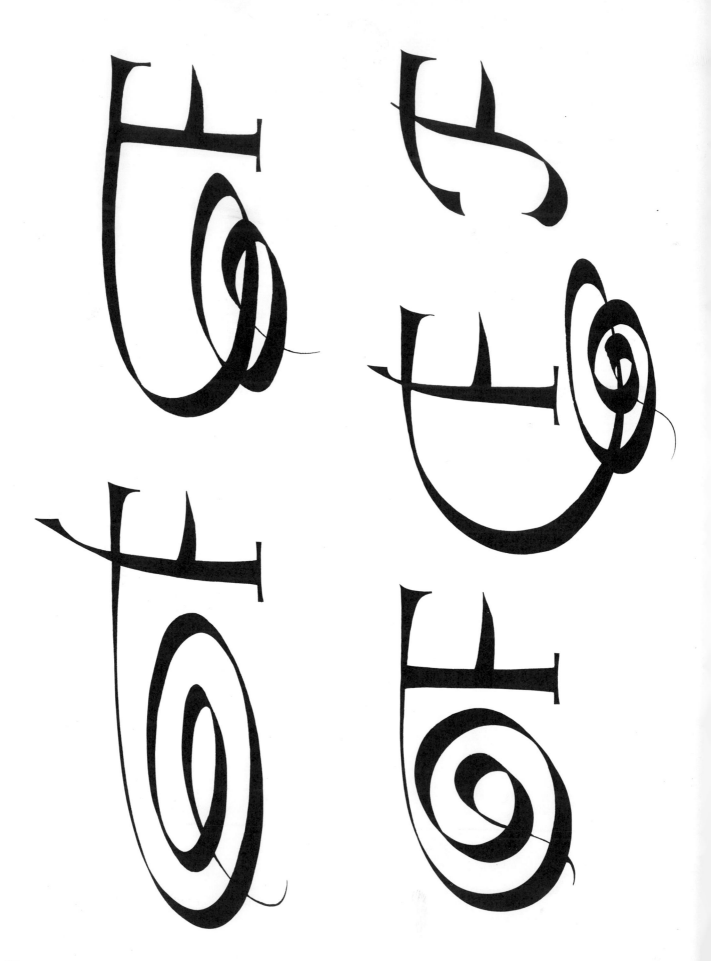

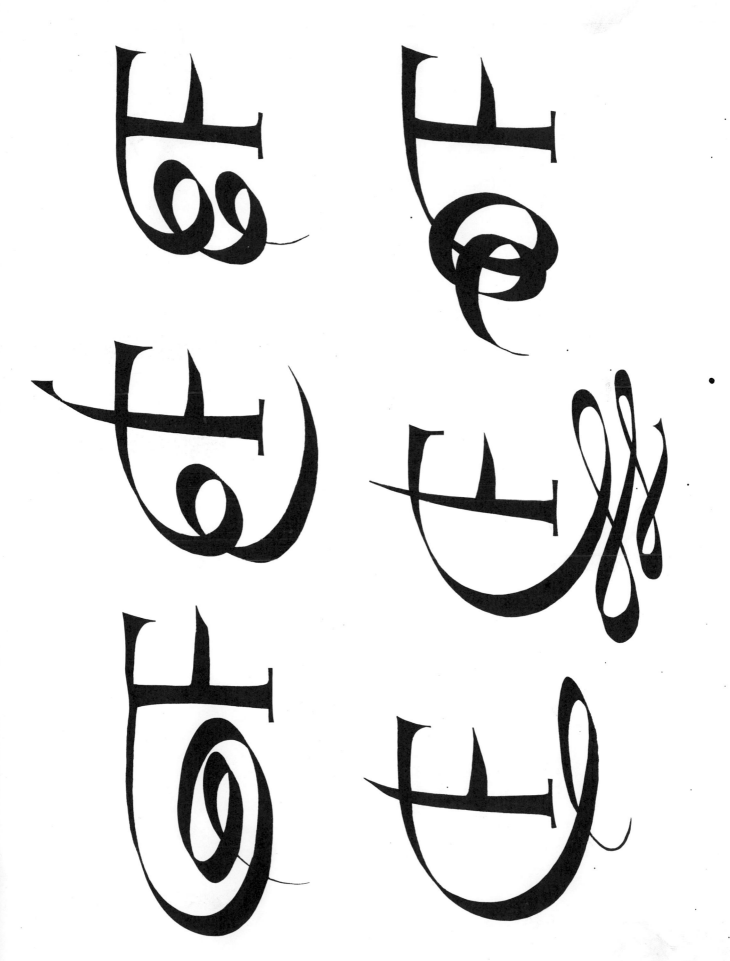

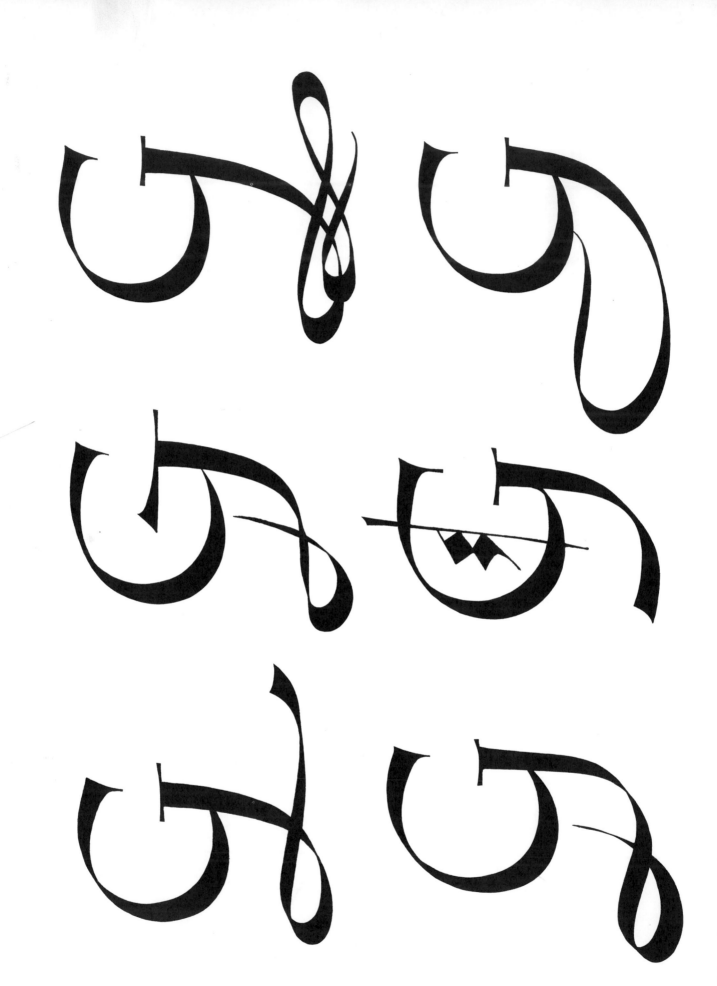

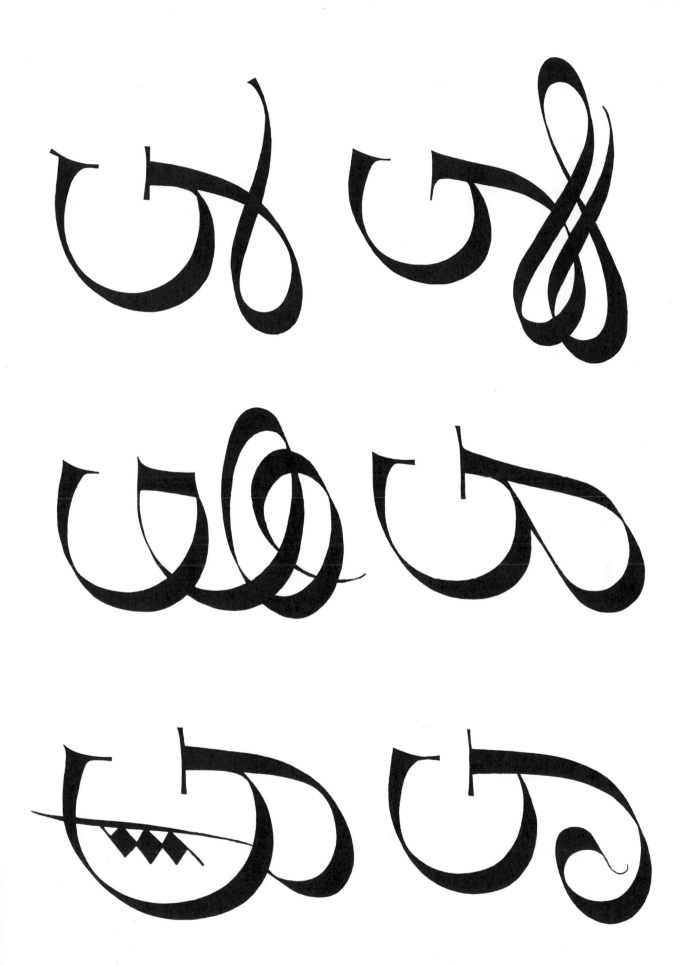

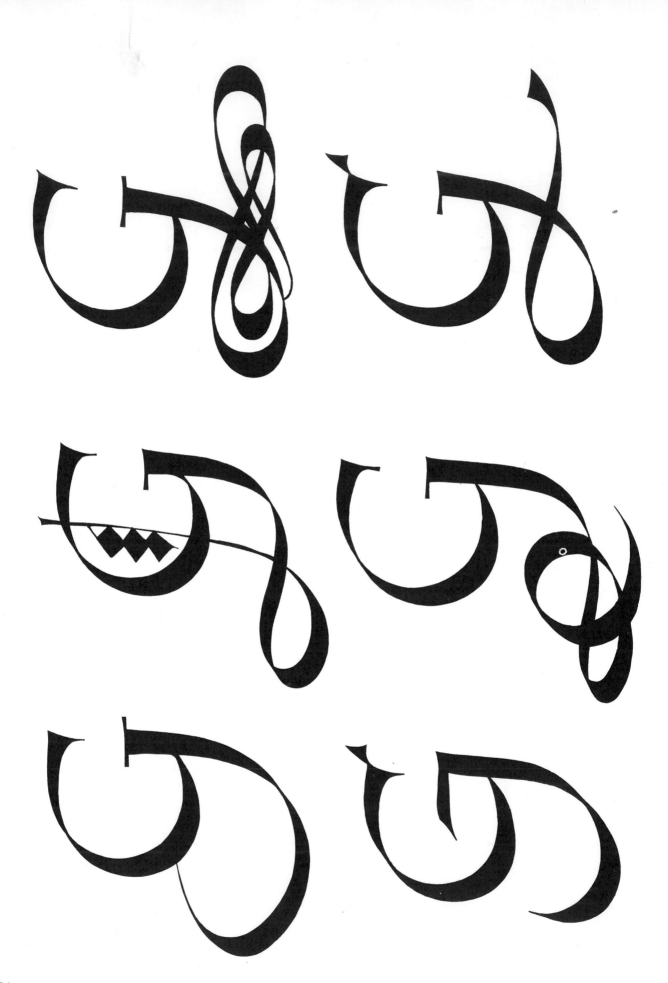

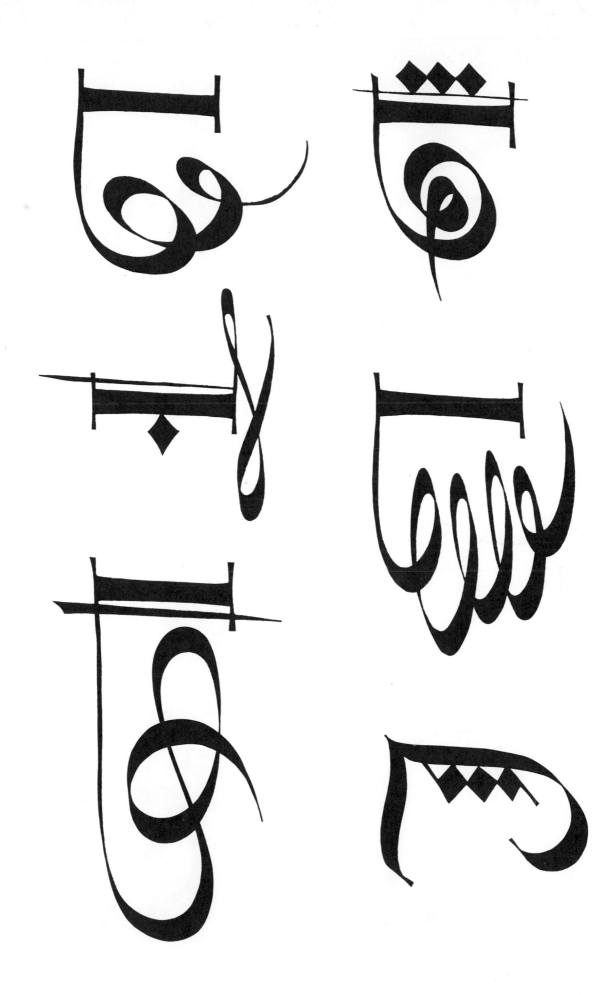

29

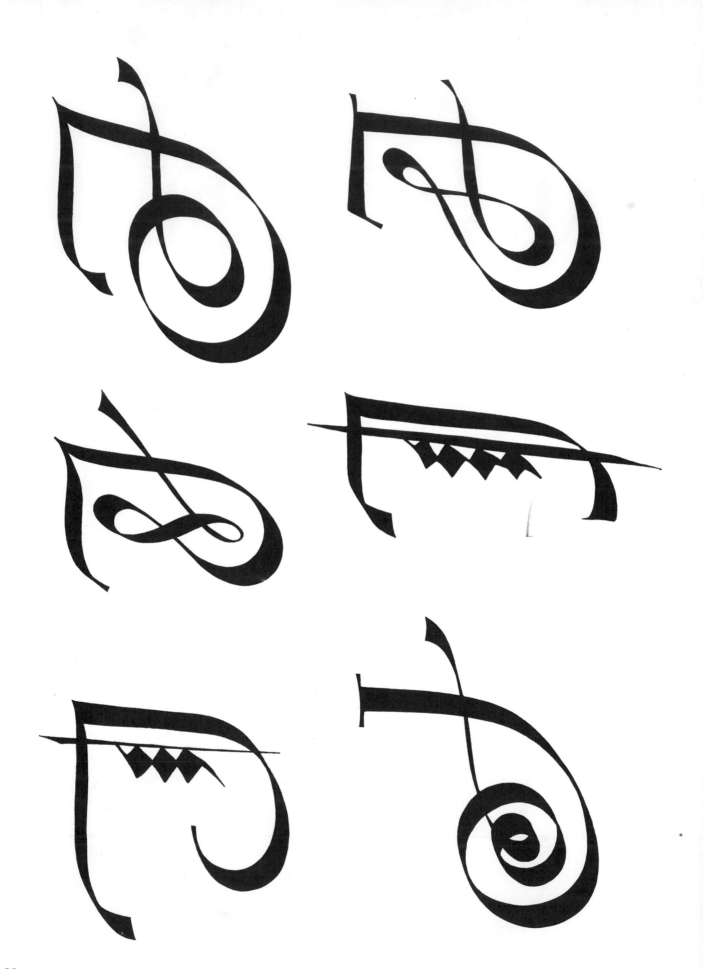

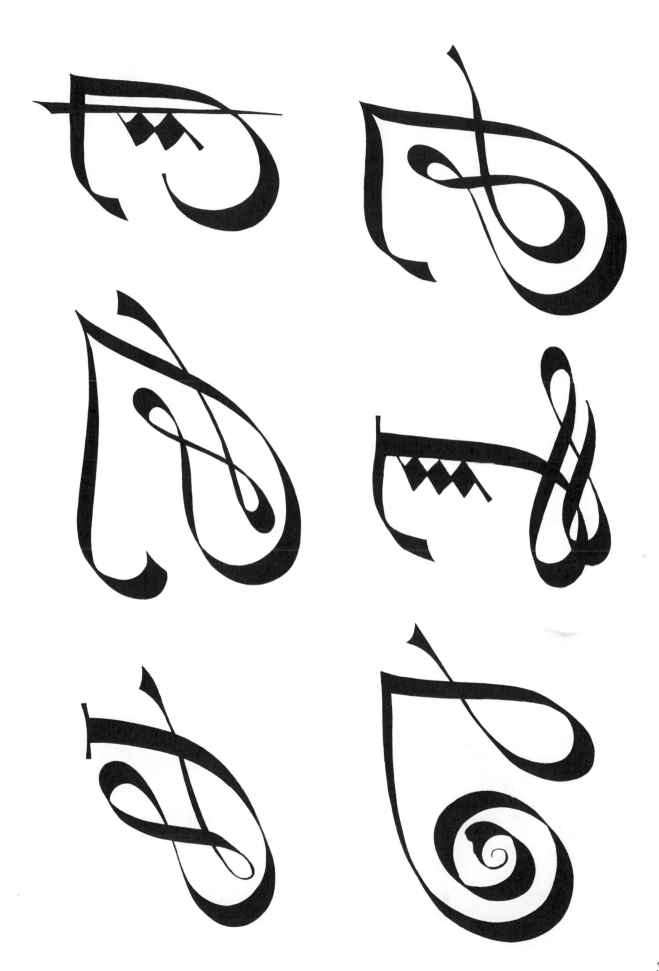

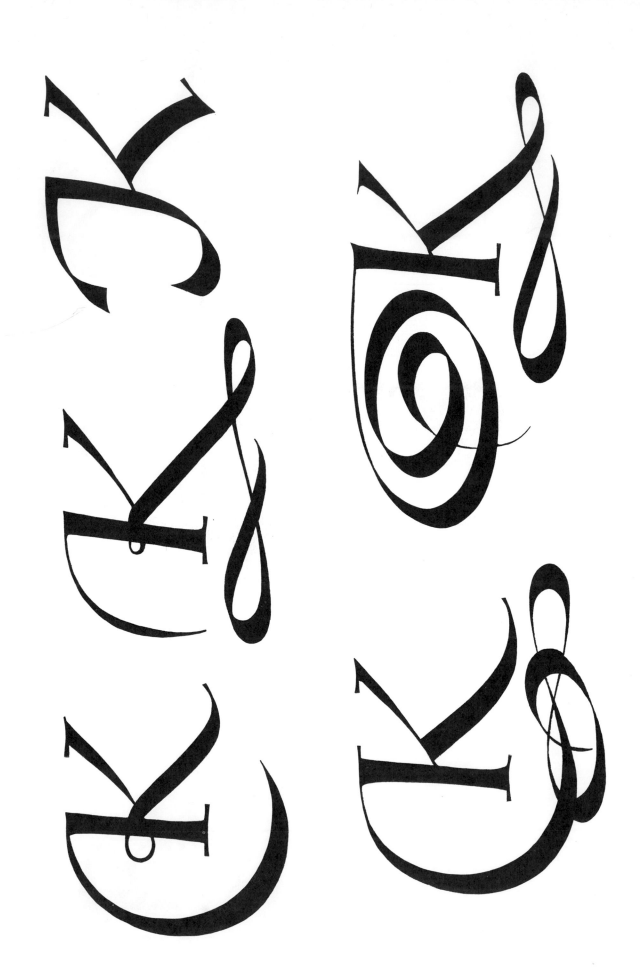

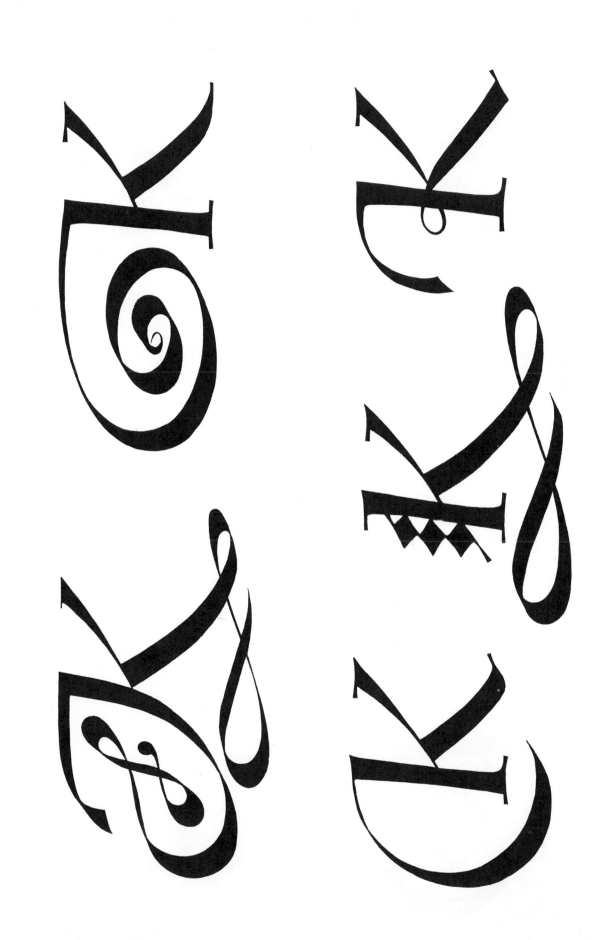

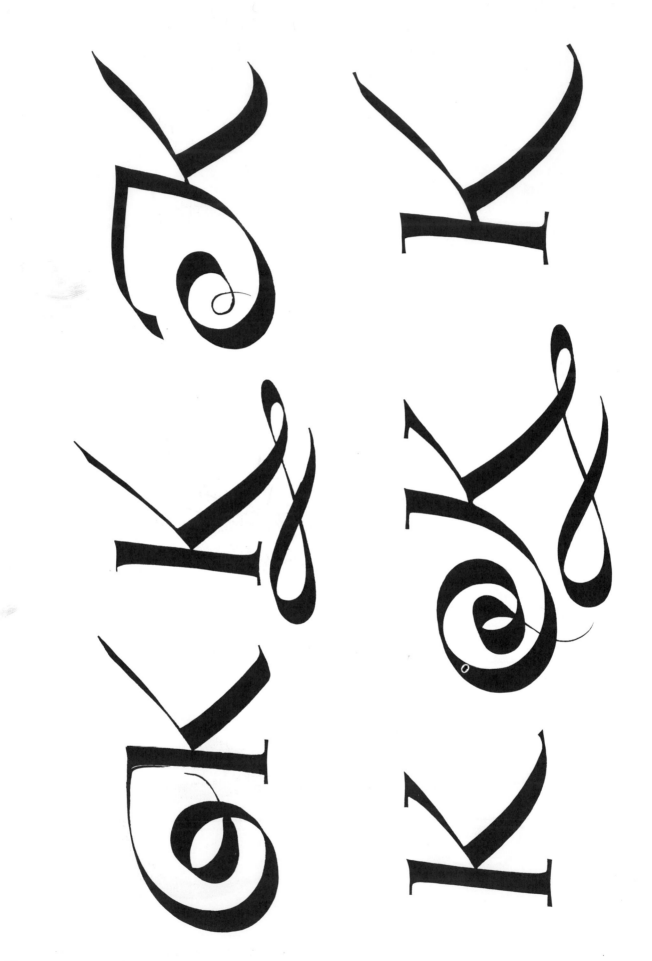

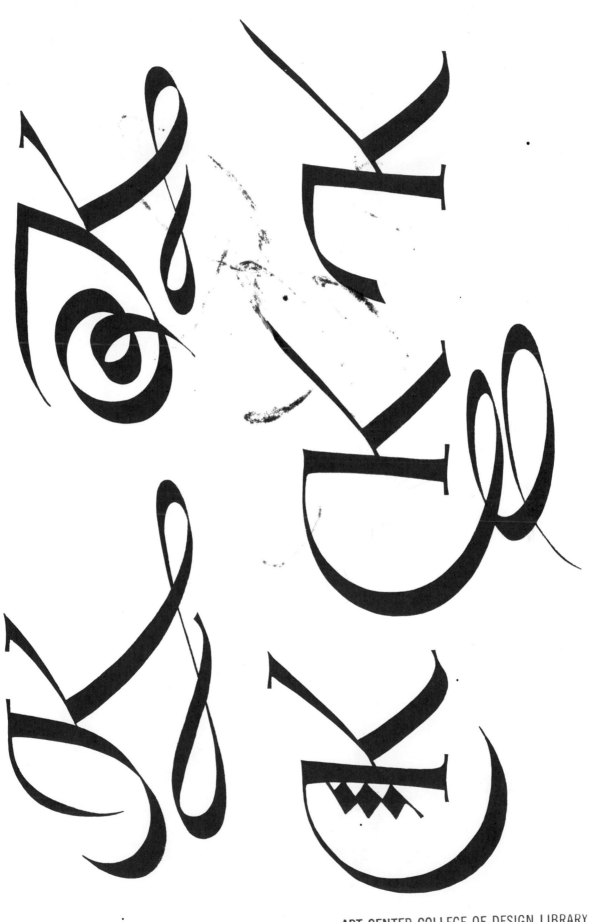

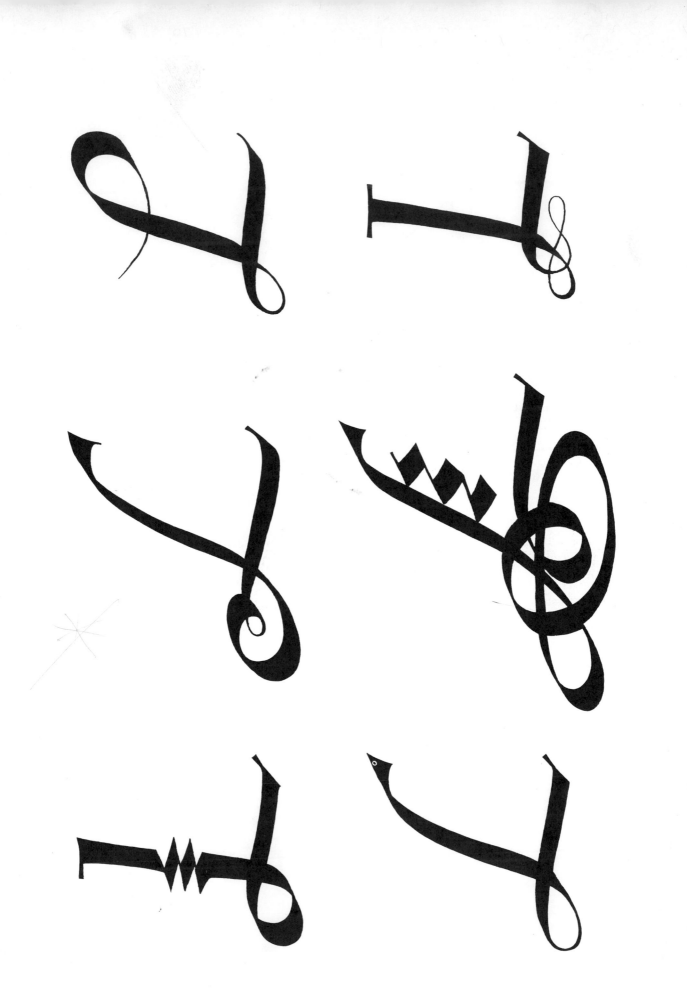

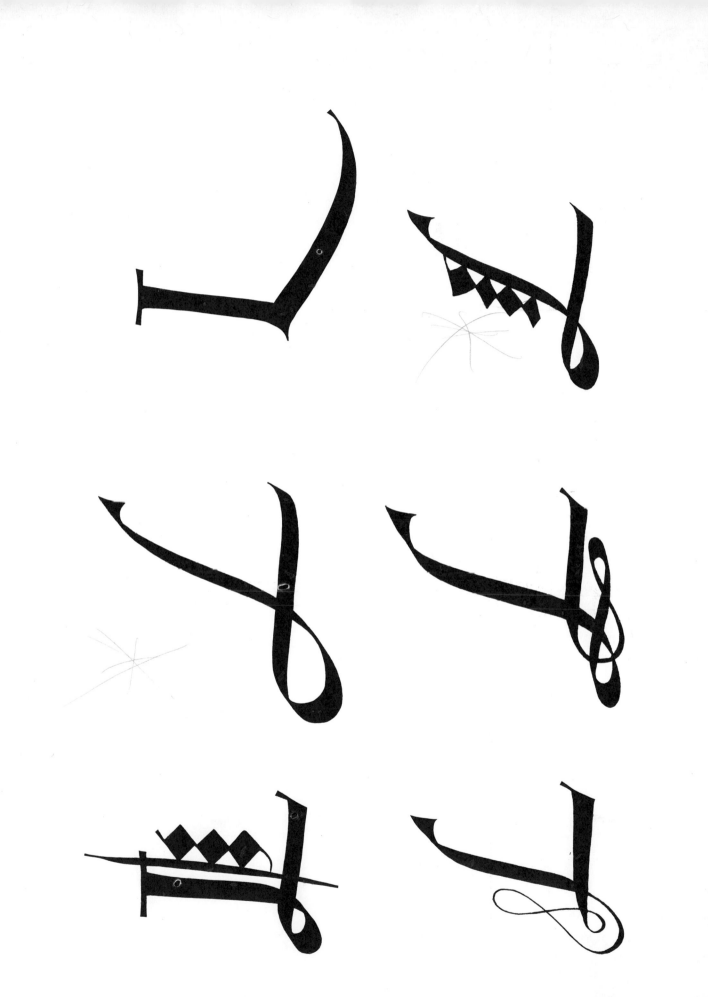

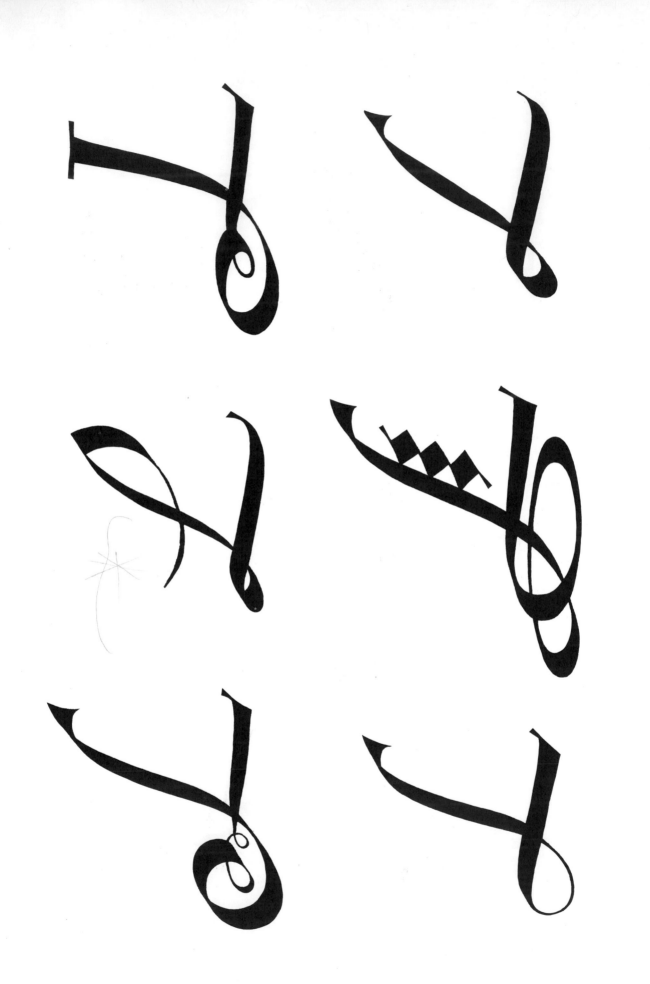

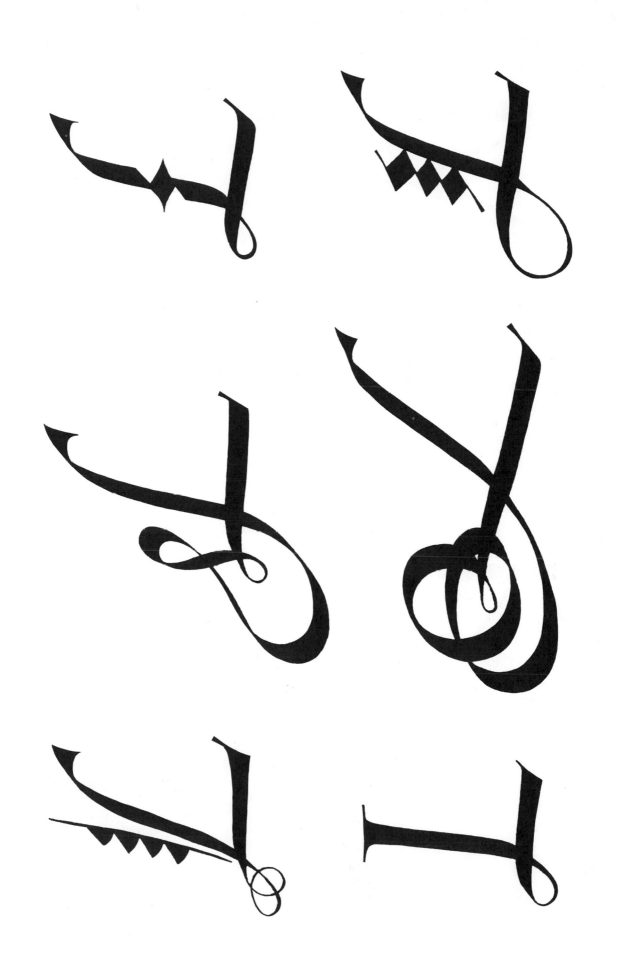

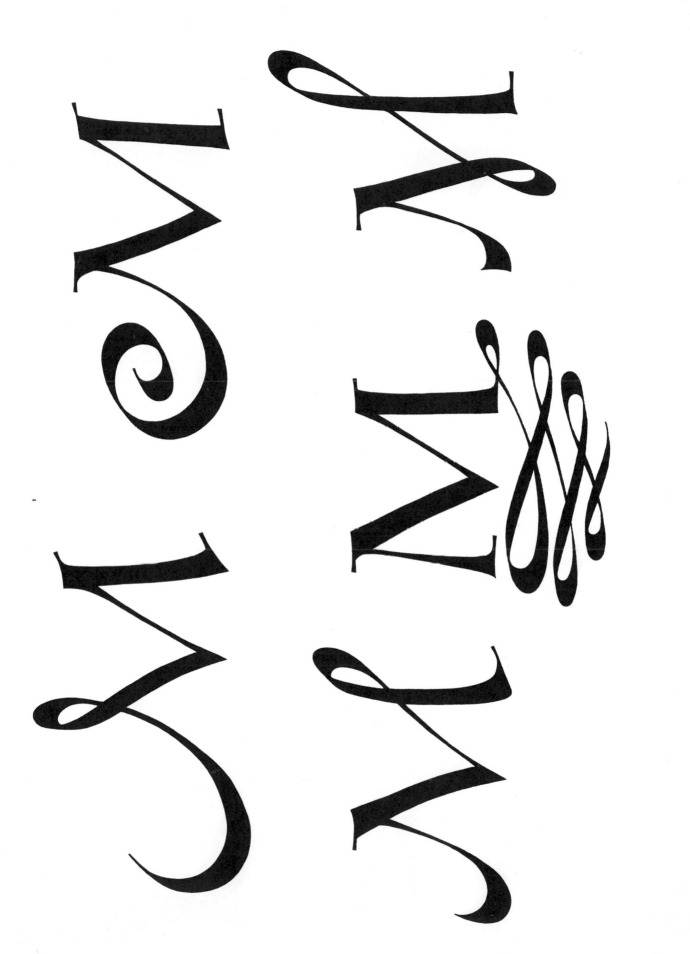

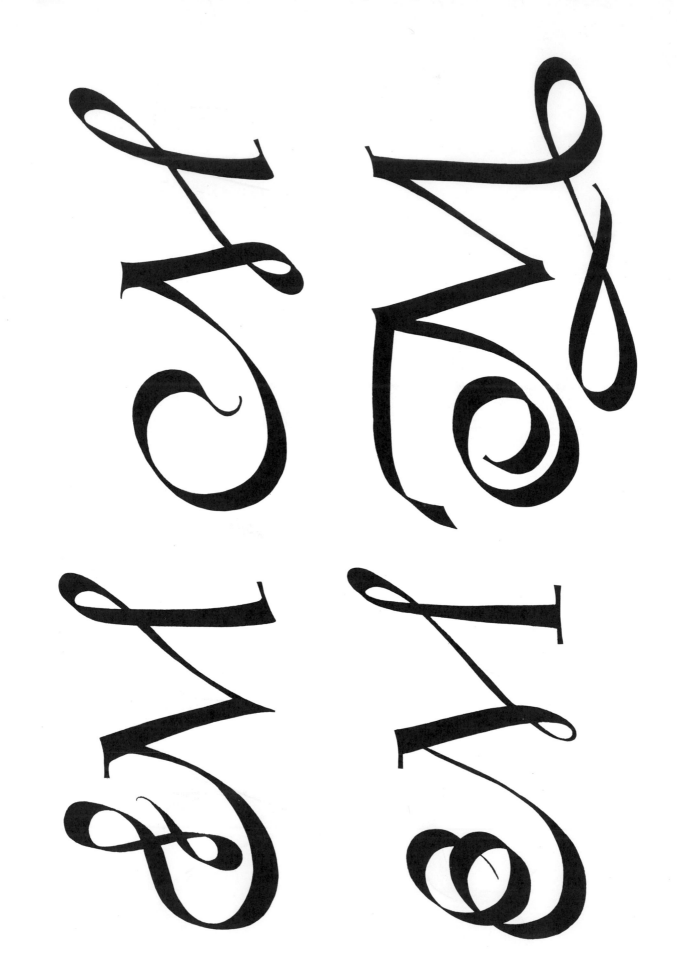

42

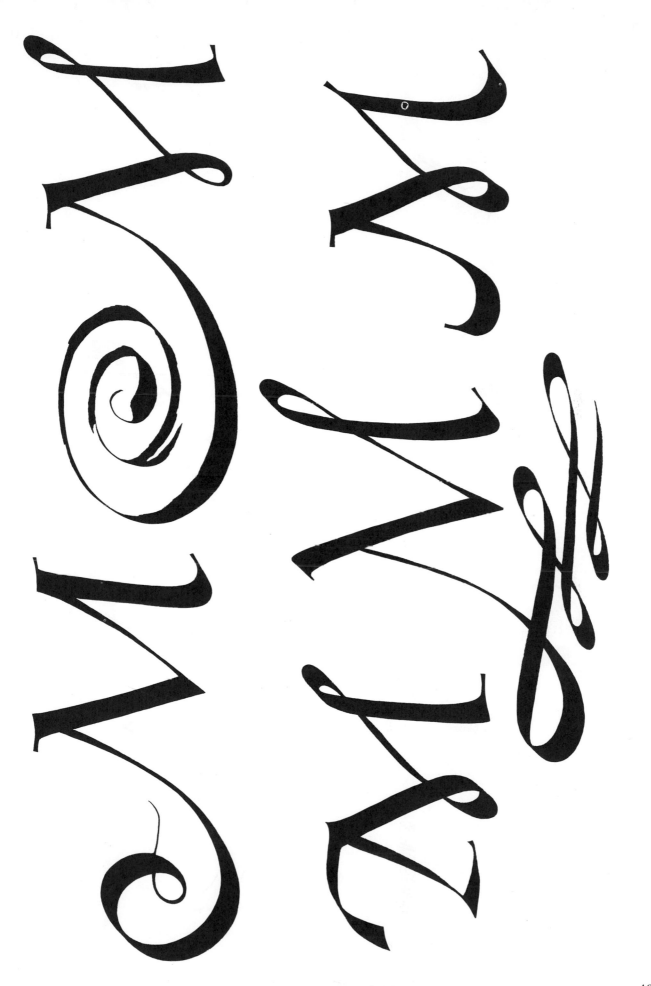

43

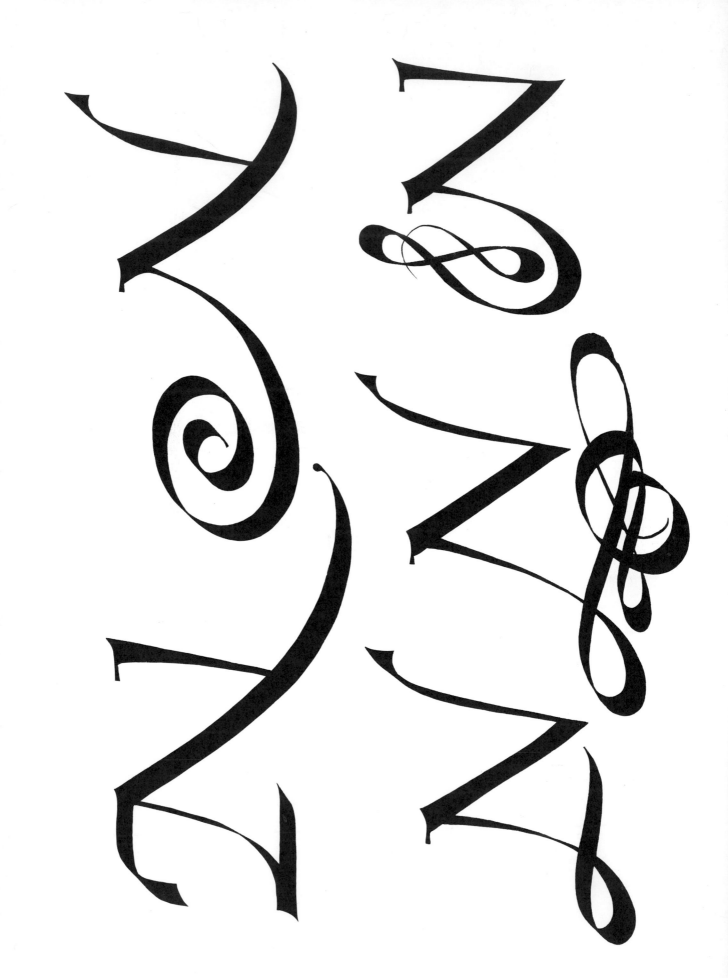

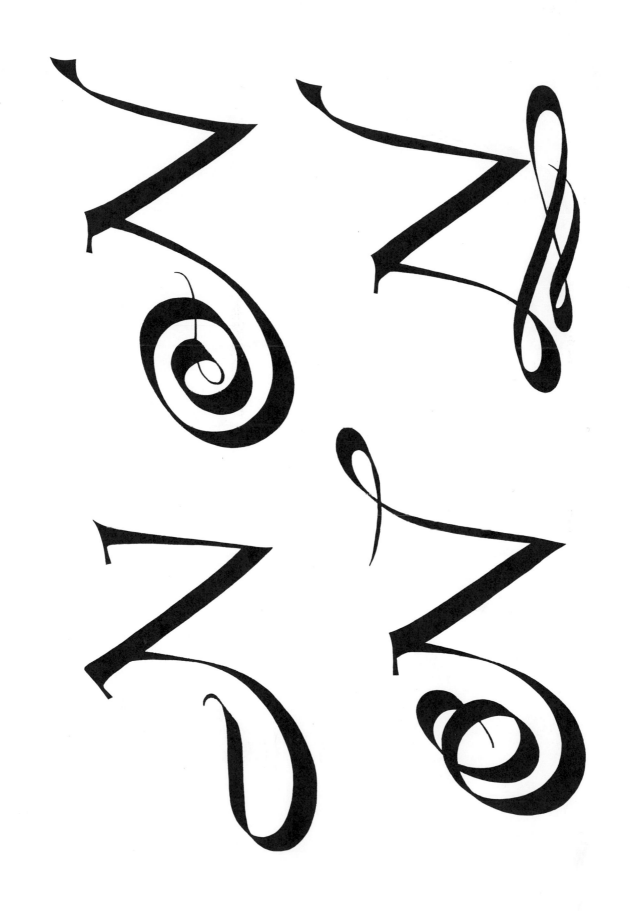

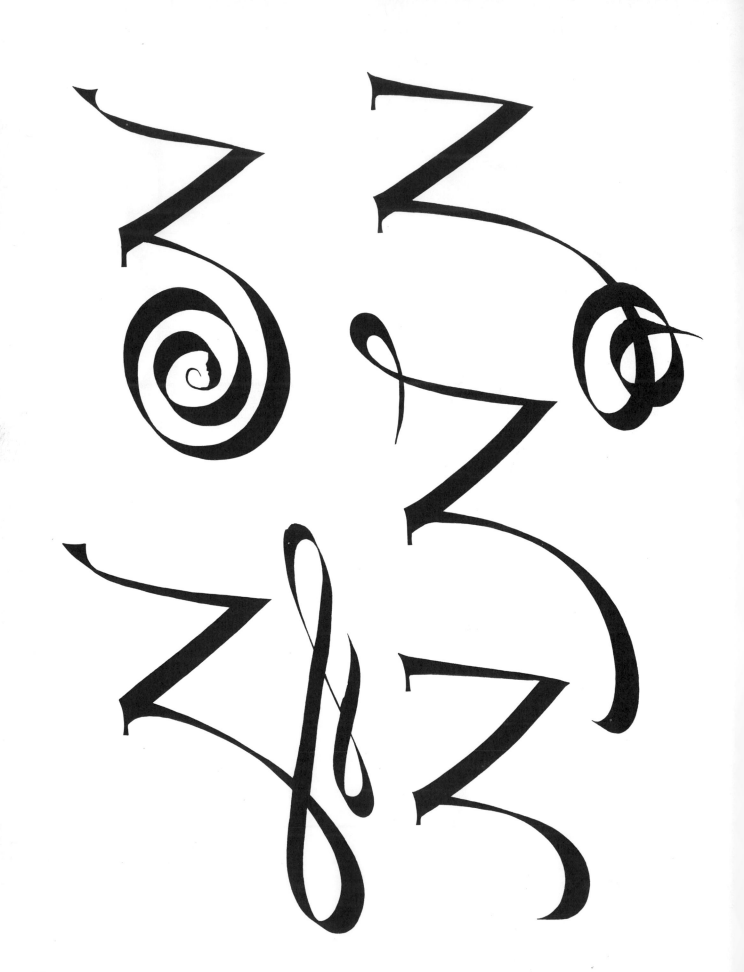

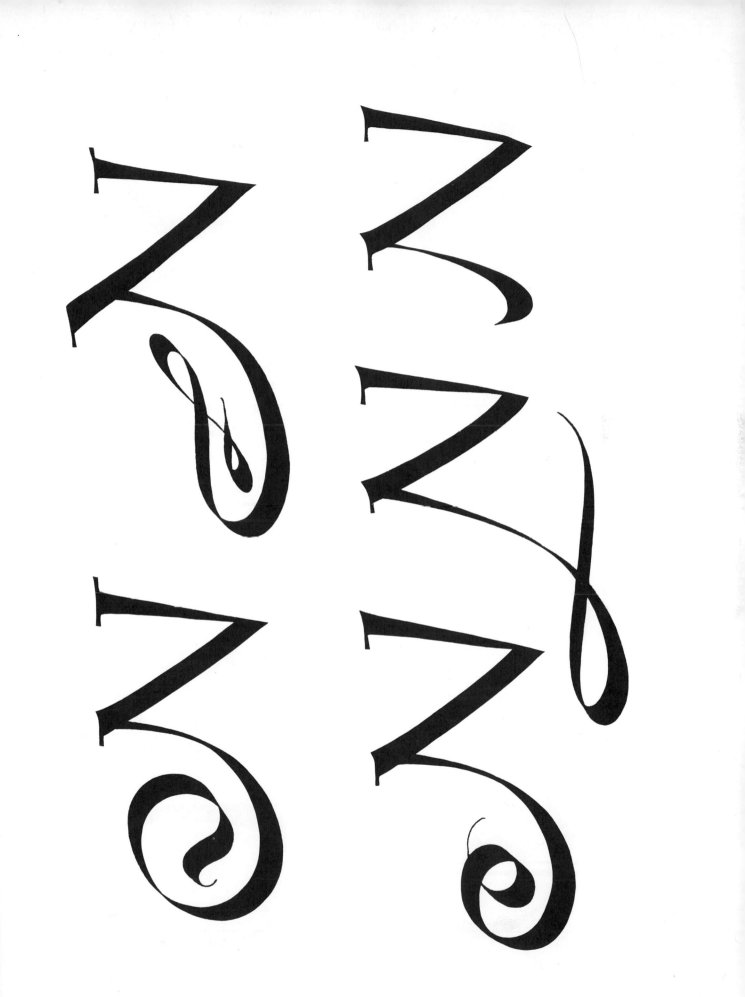

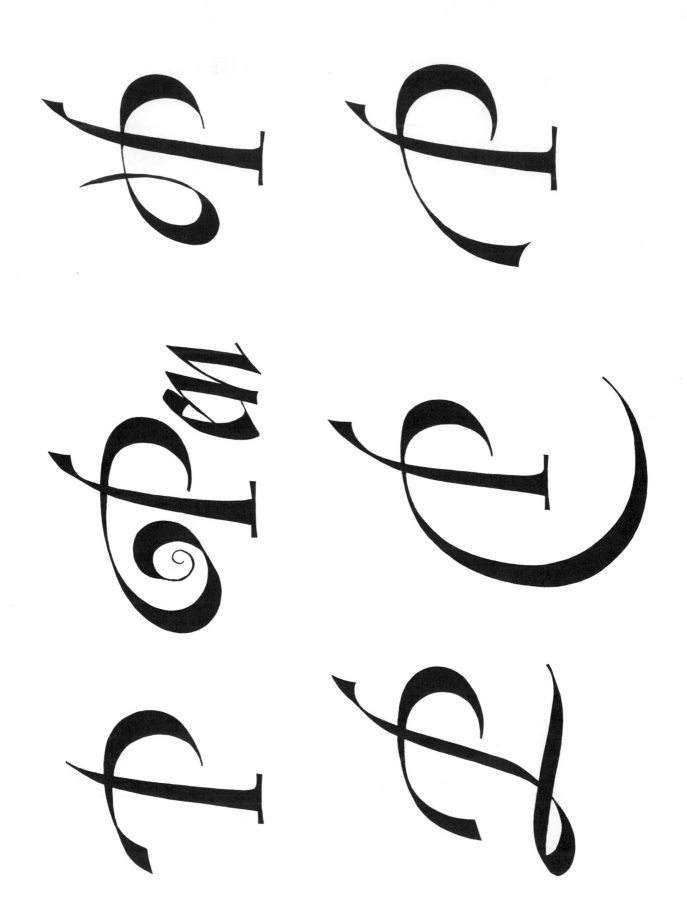

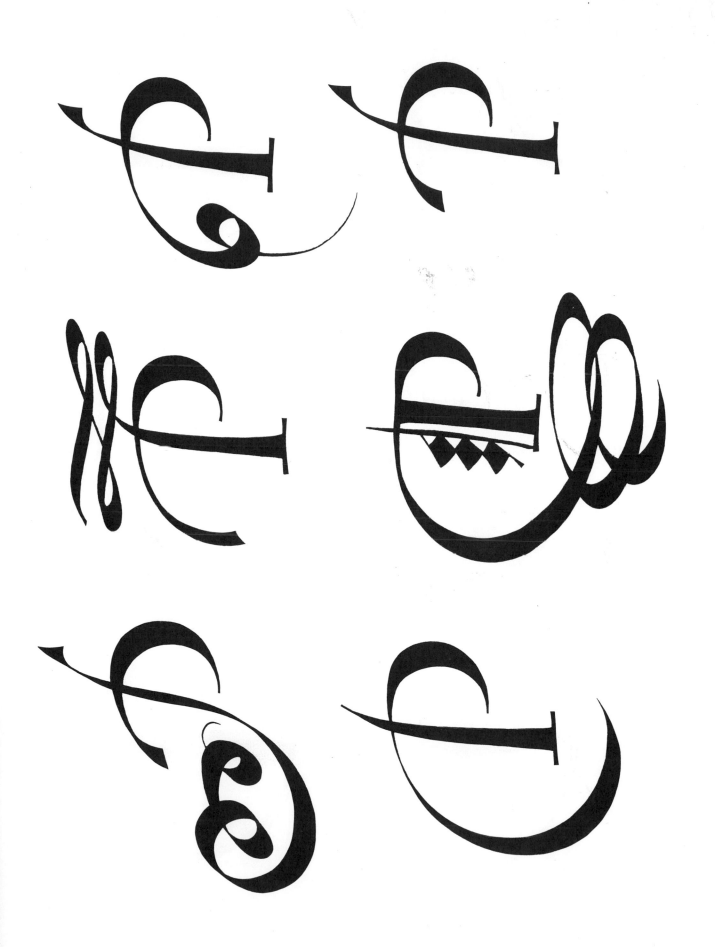

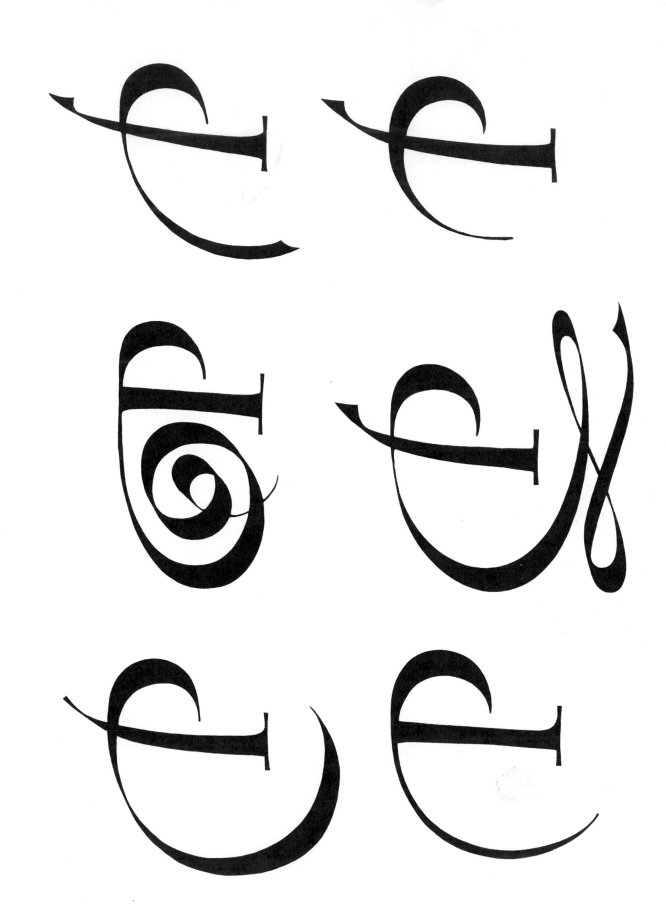

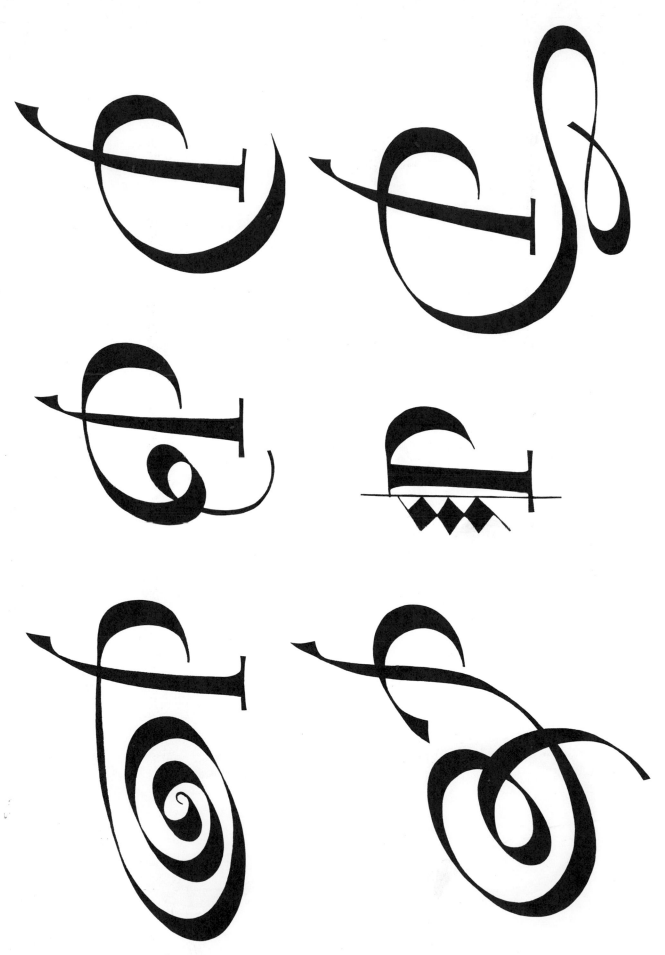

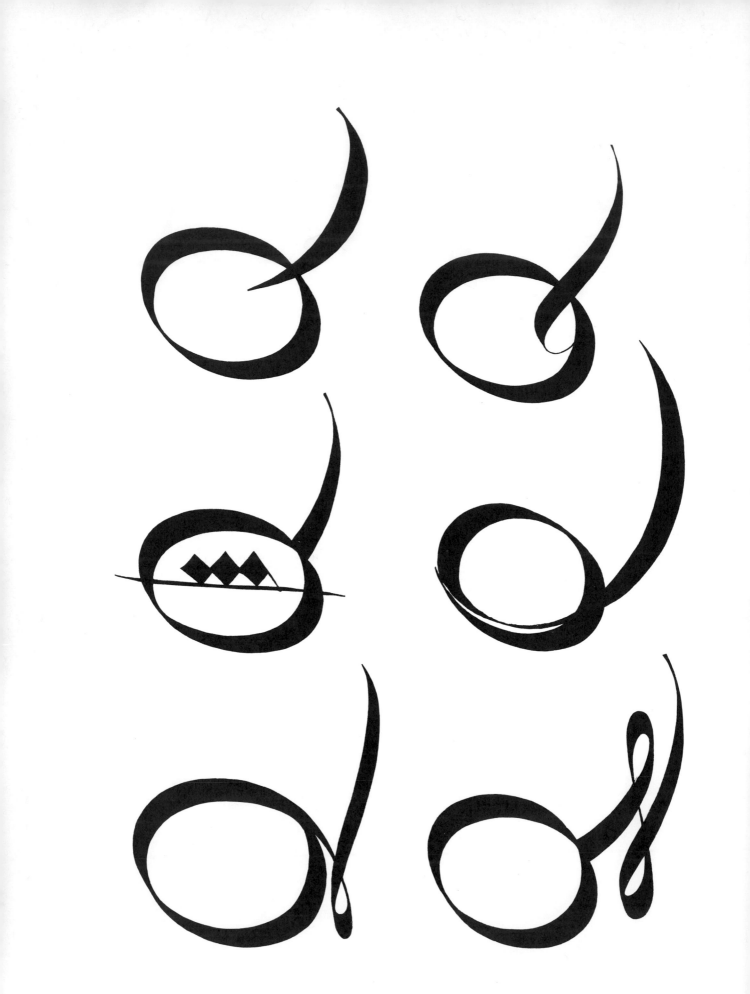

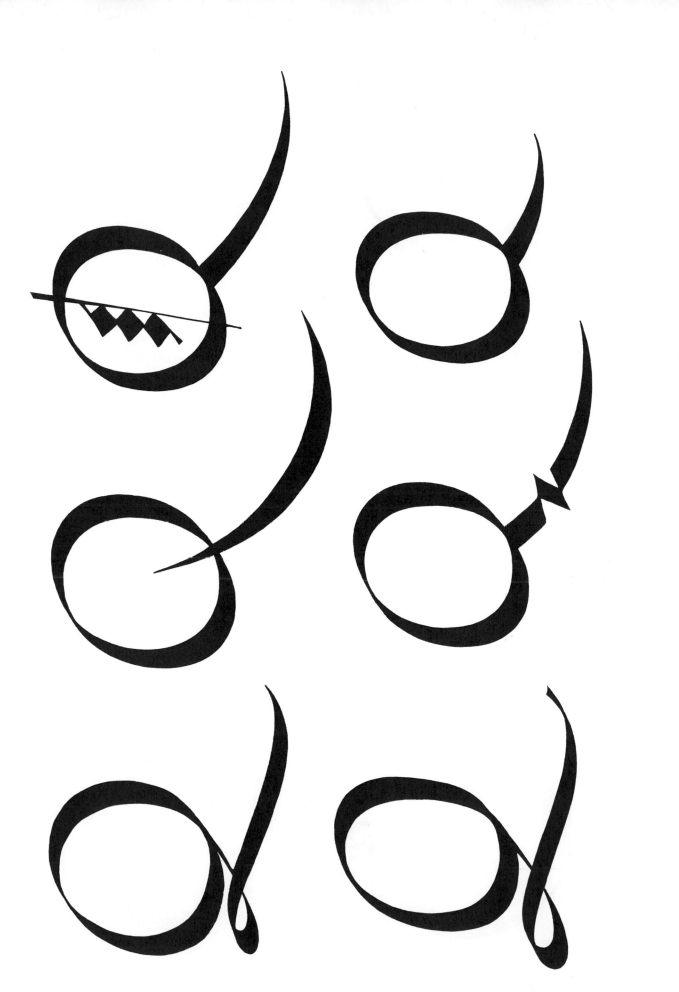

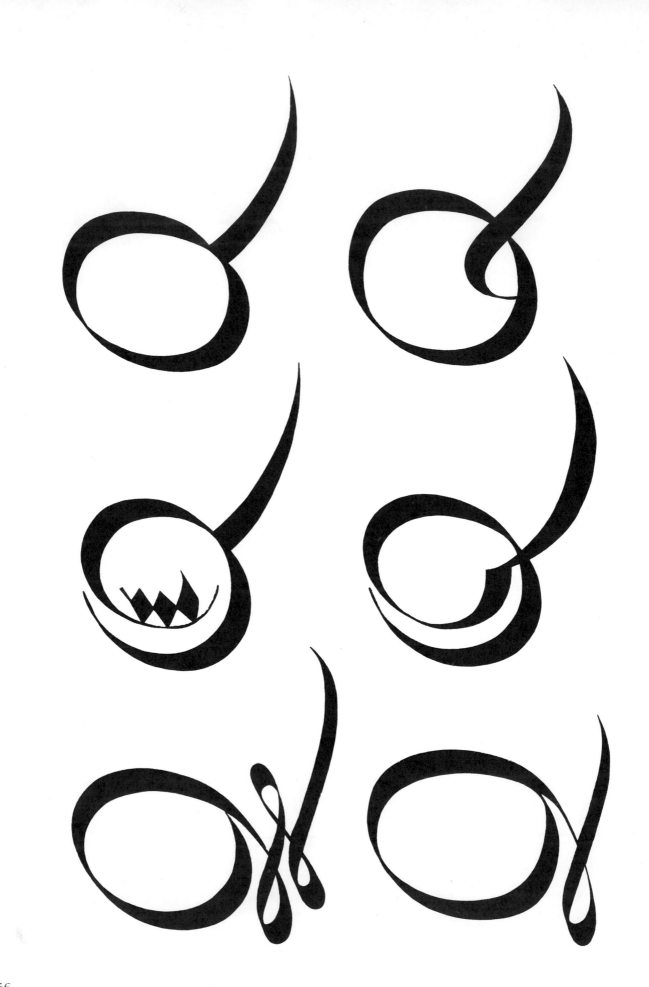

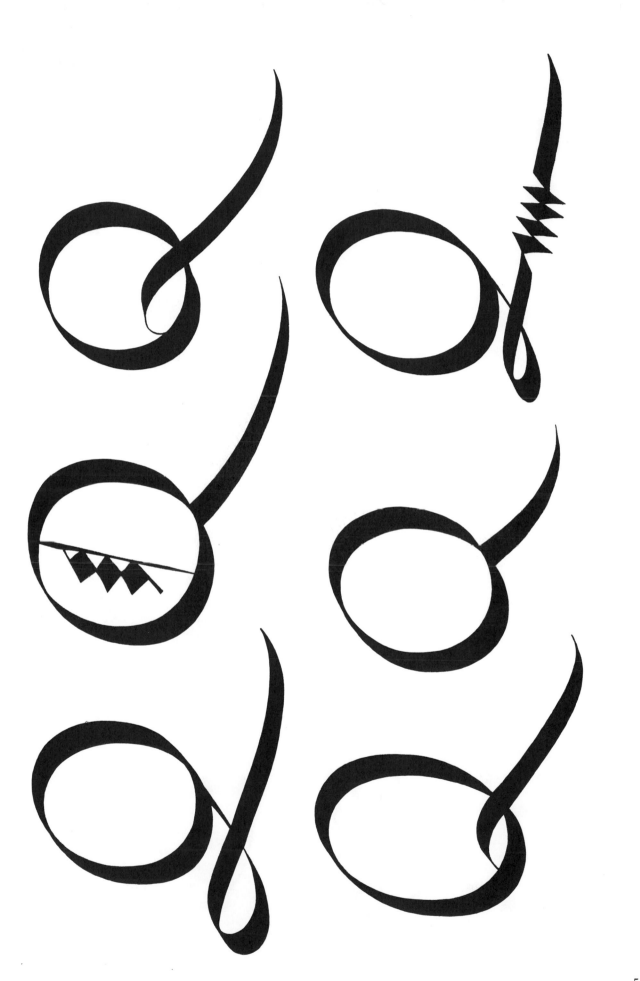

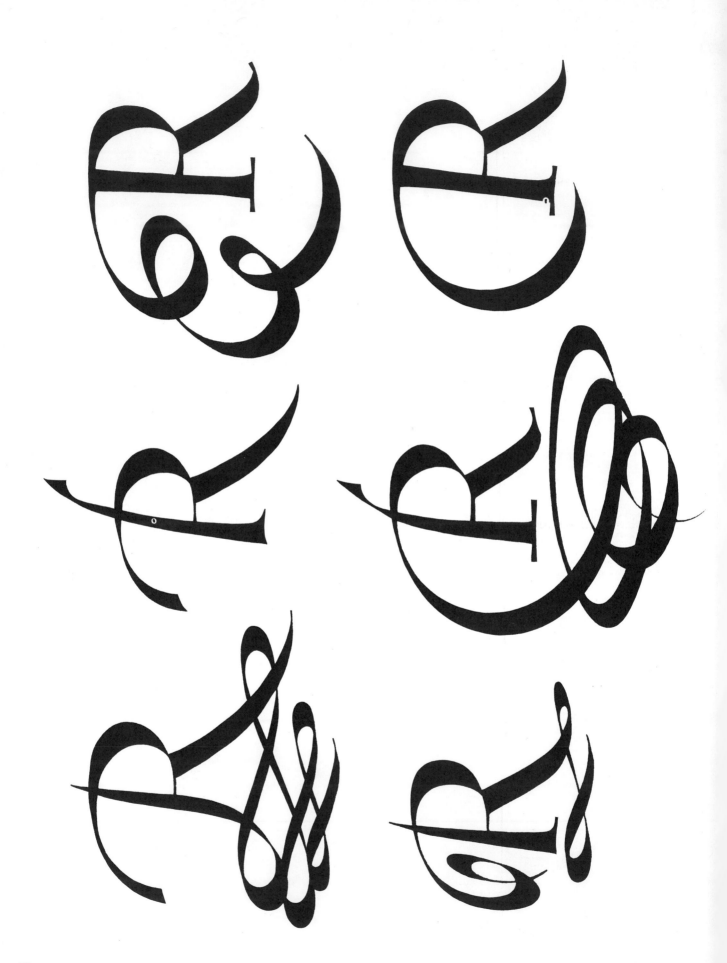

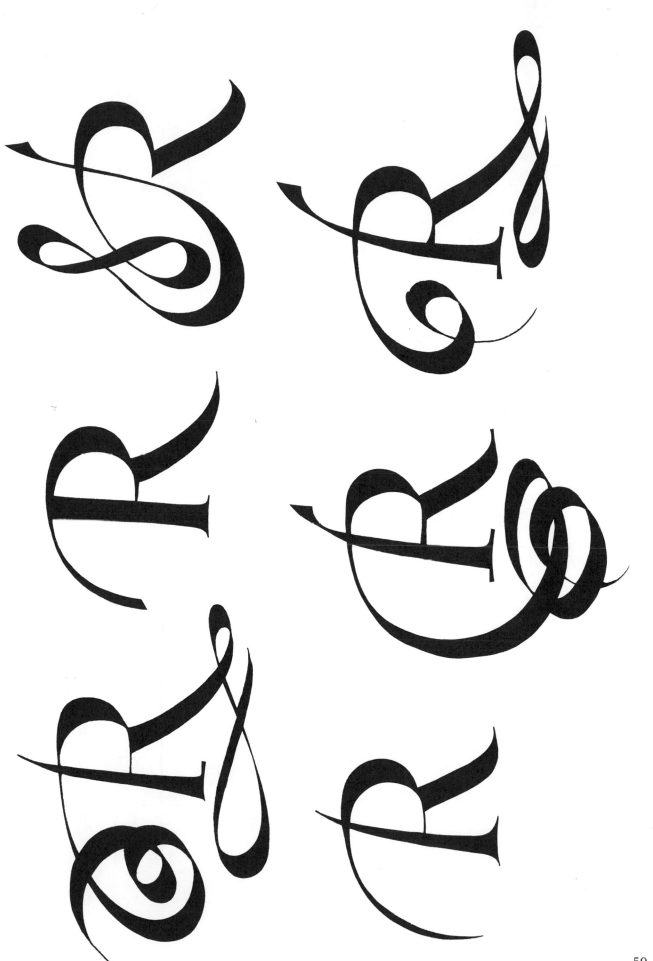

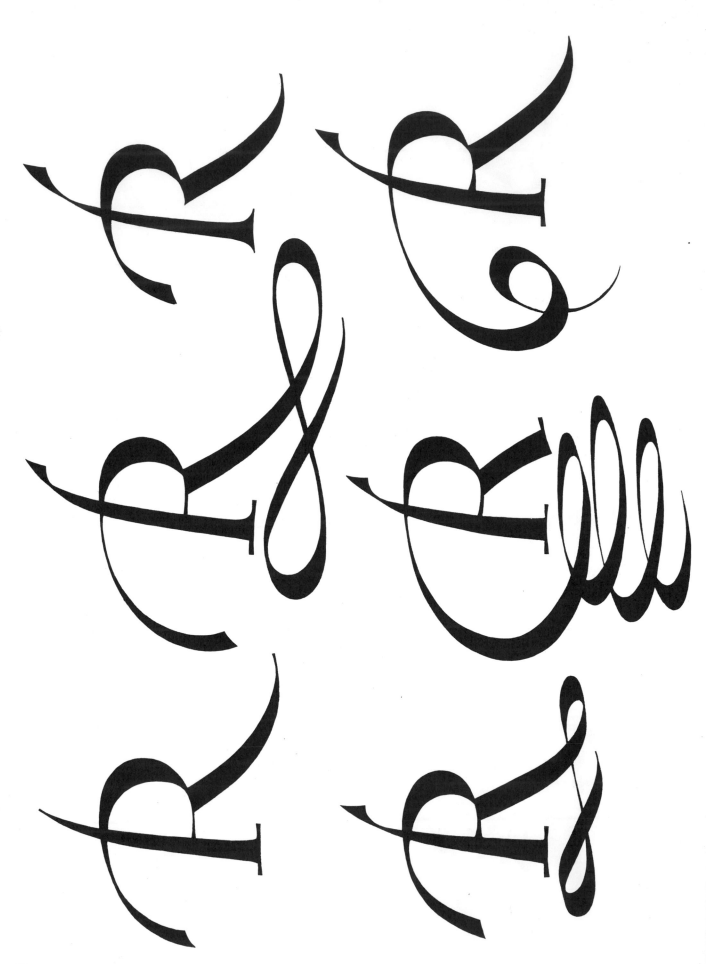

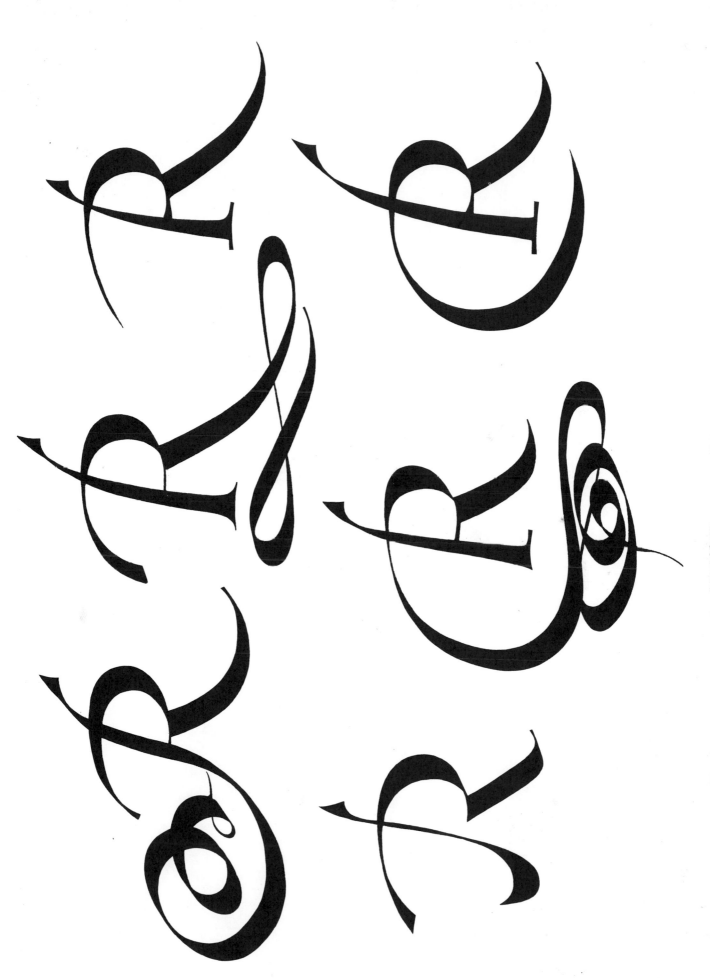

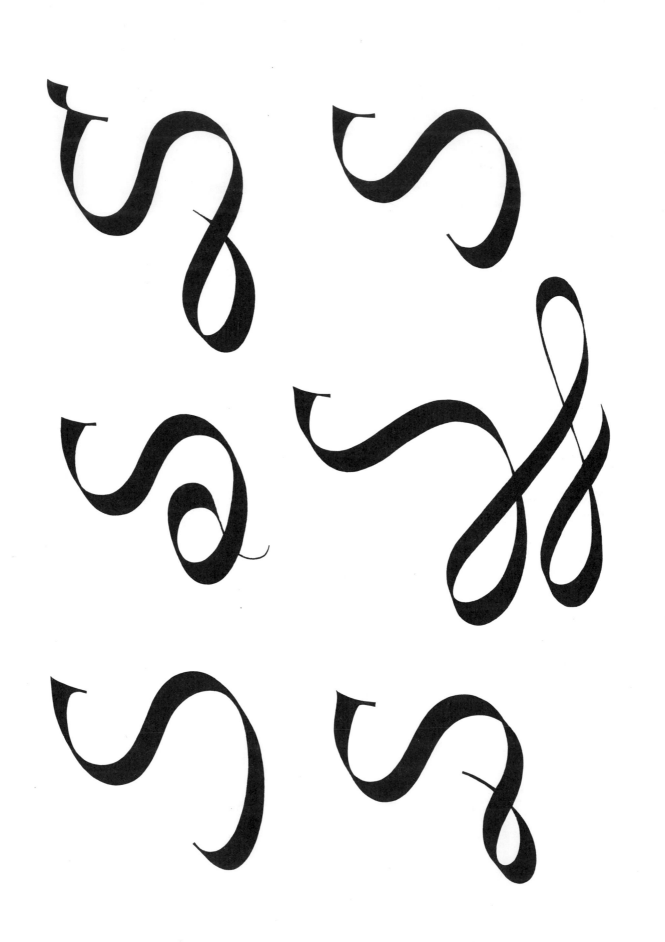

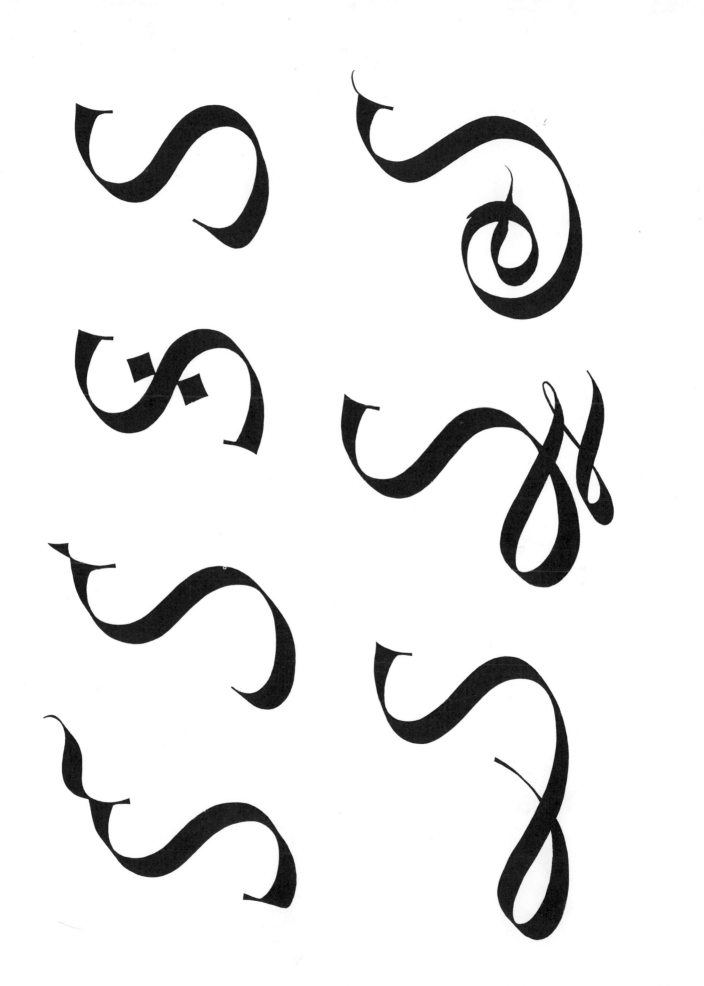

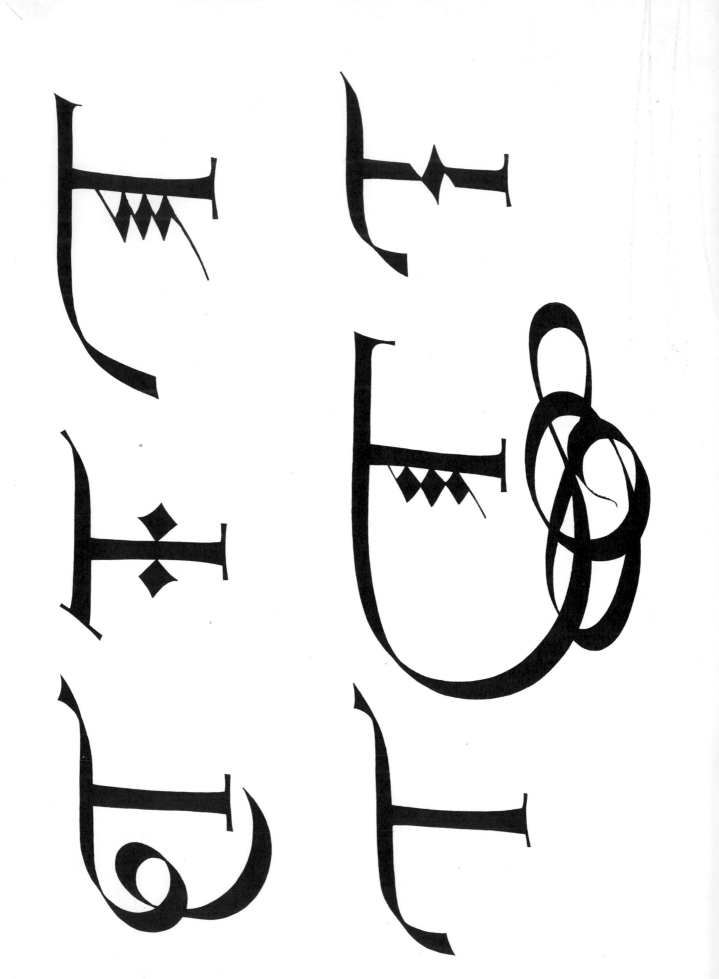

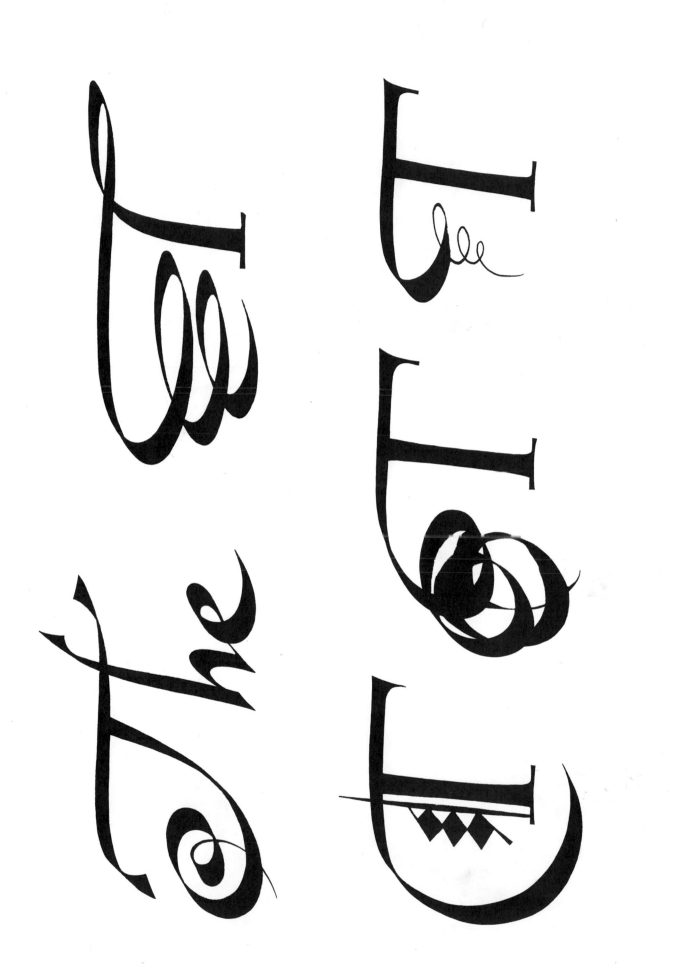

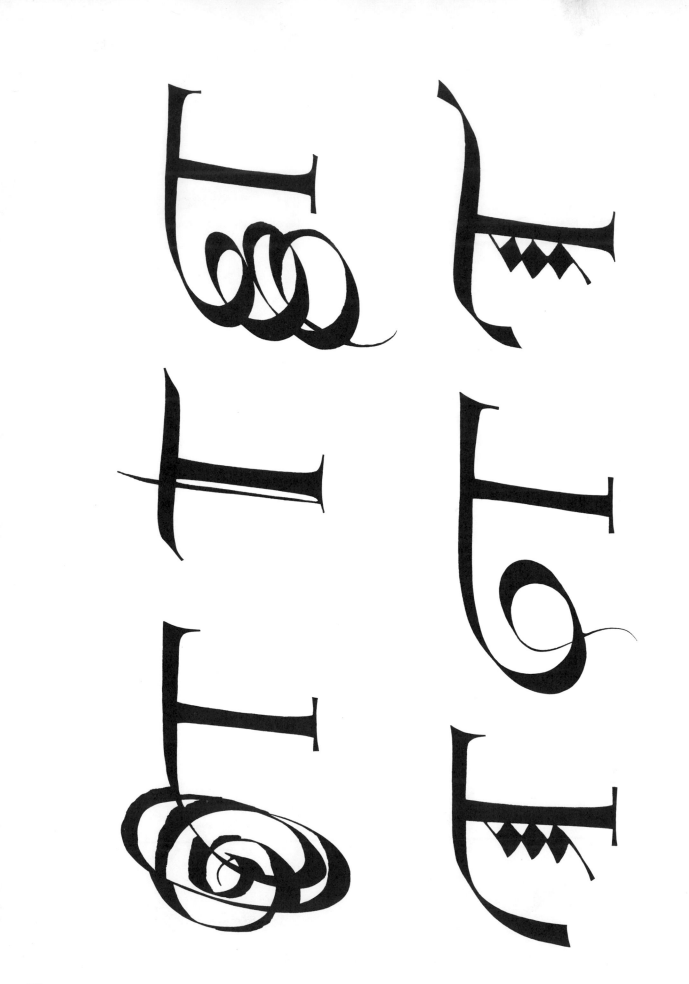

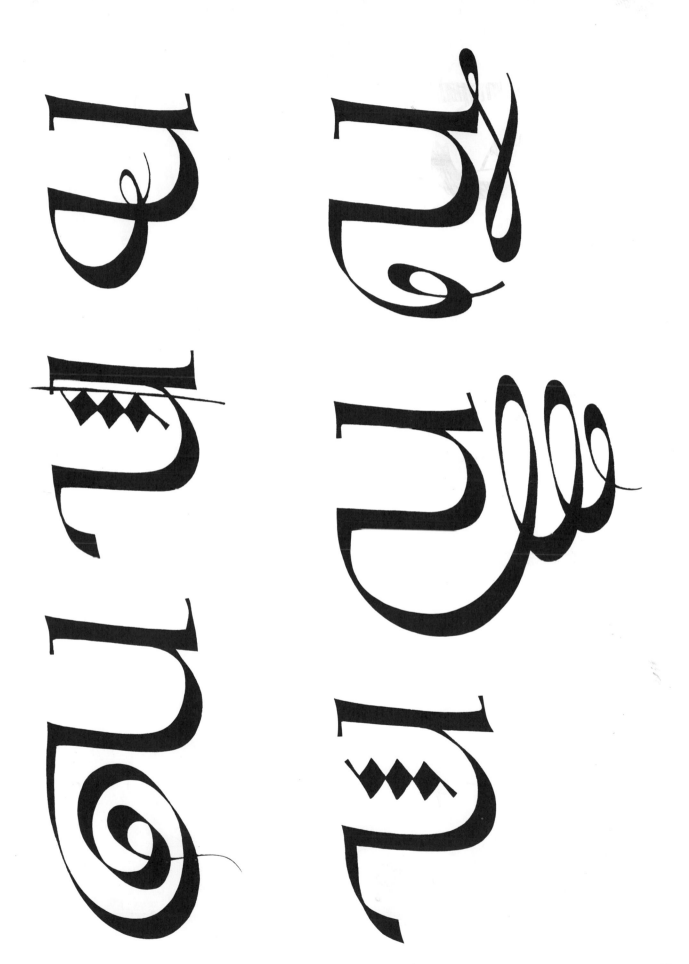

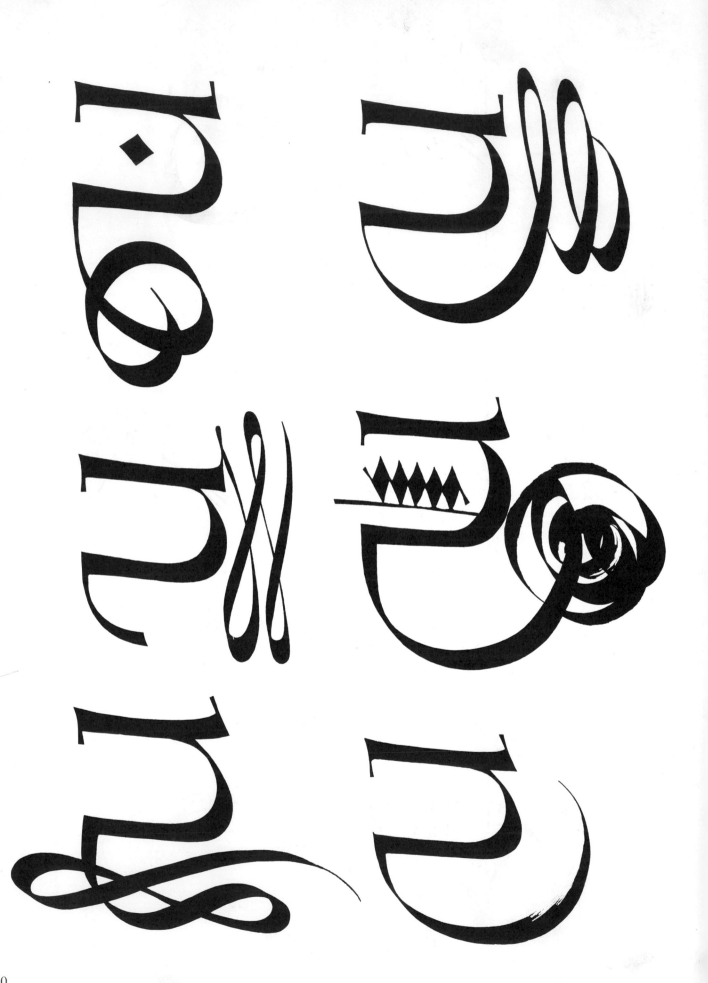

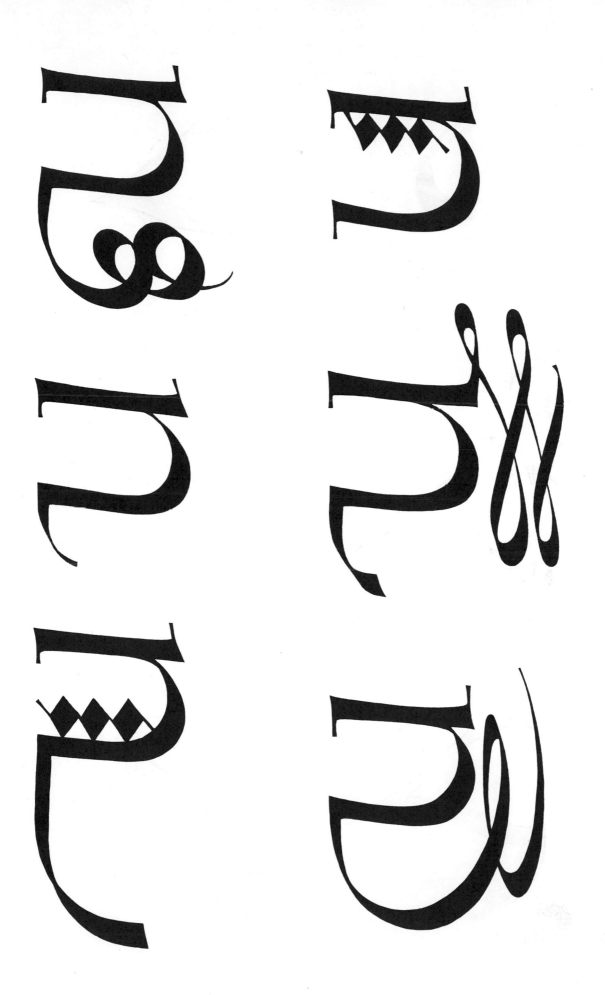

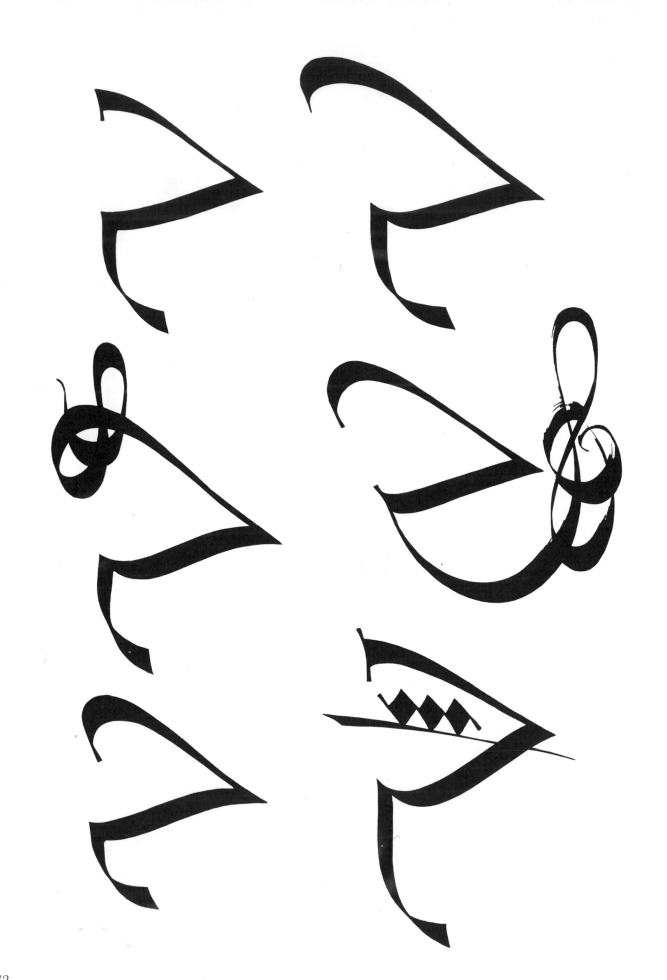

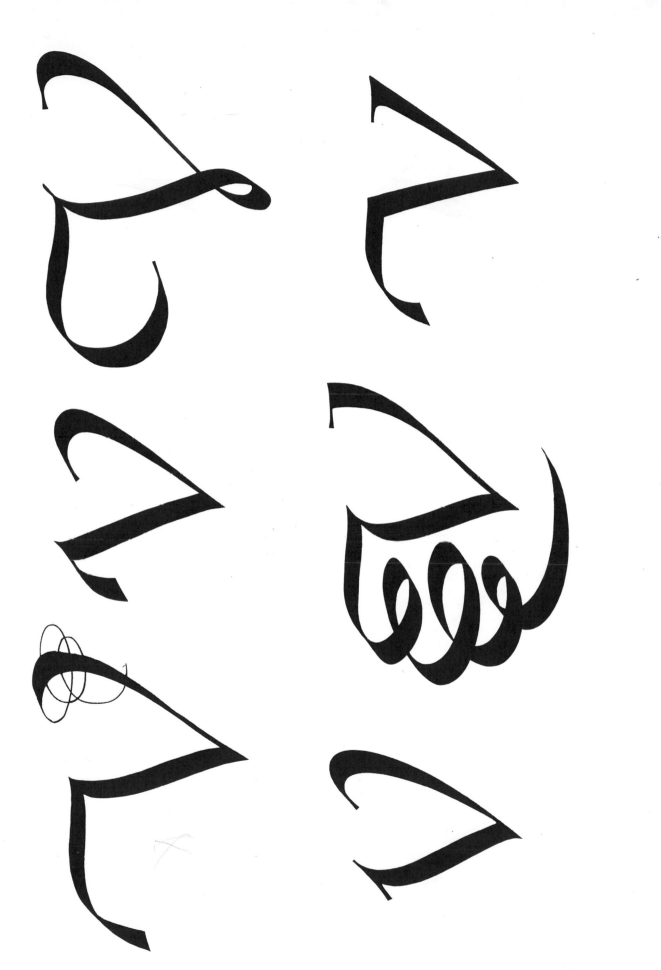

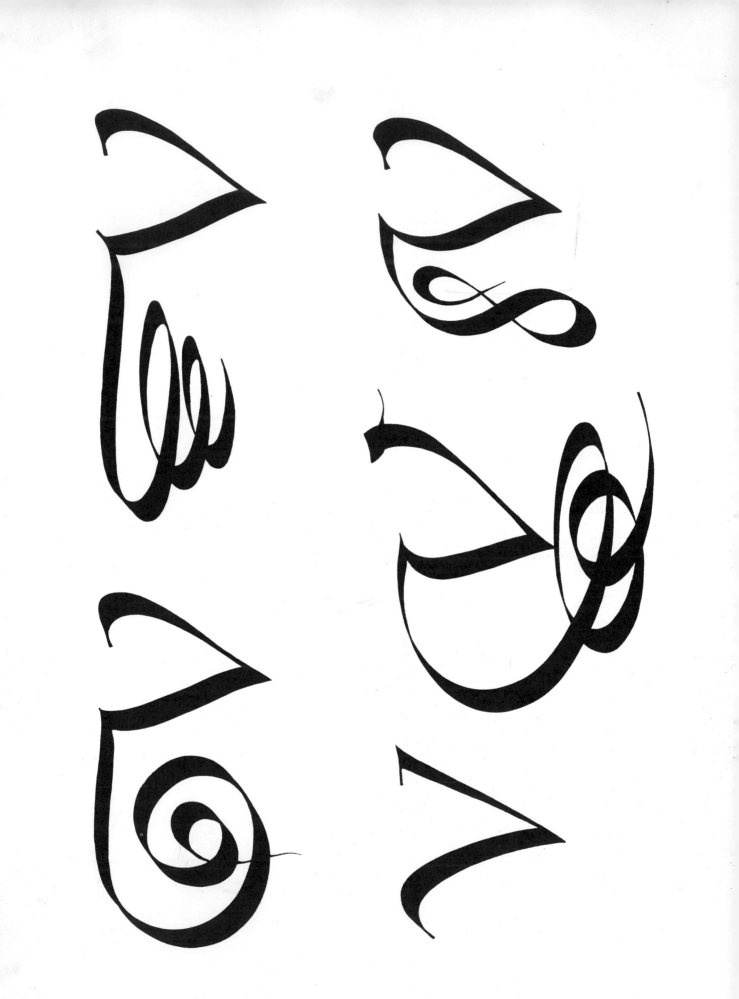

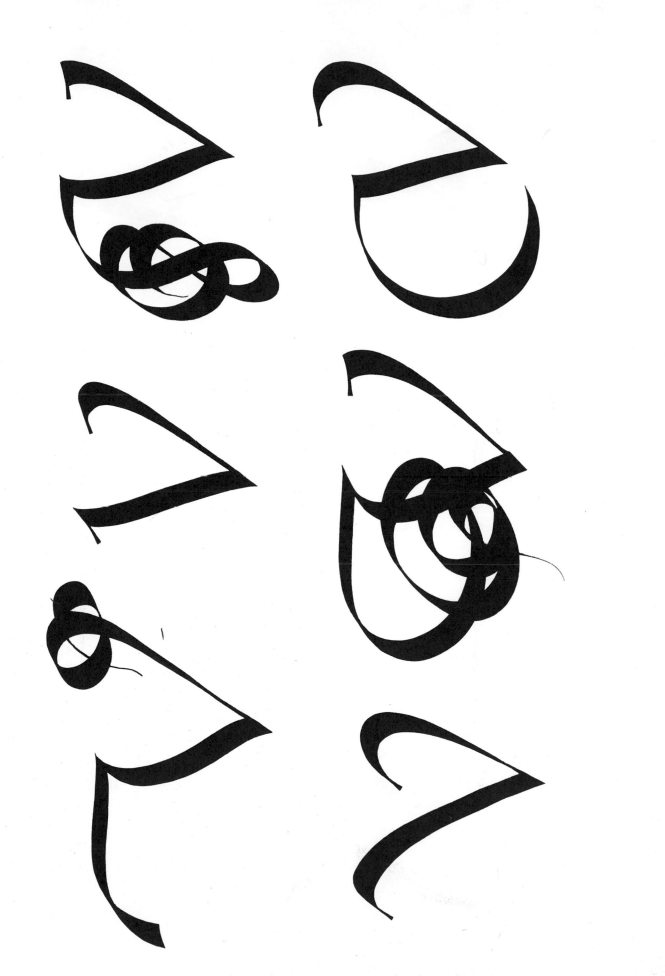

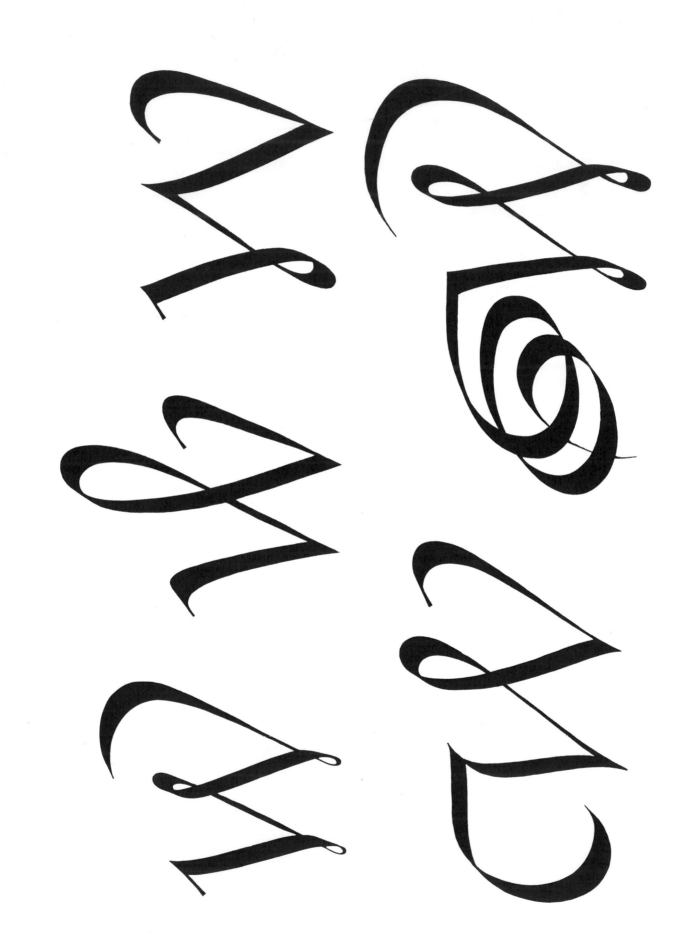

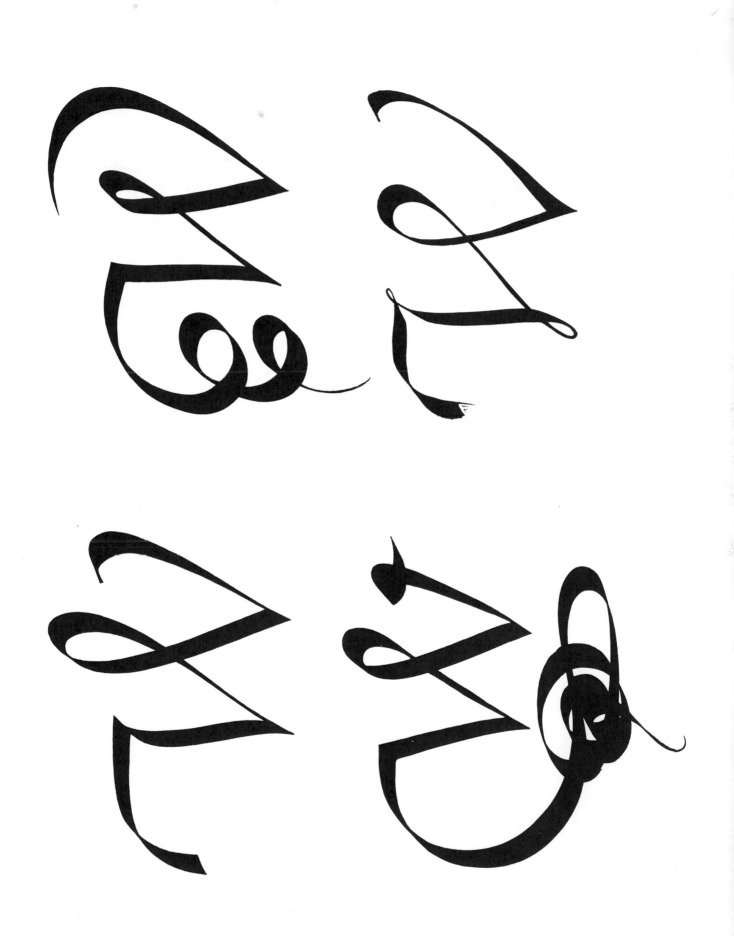

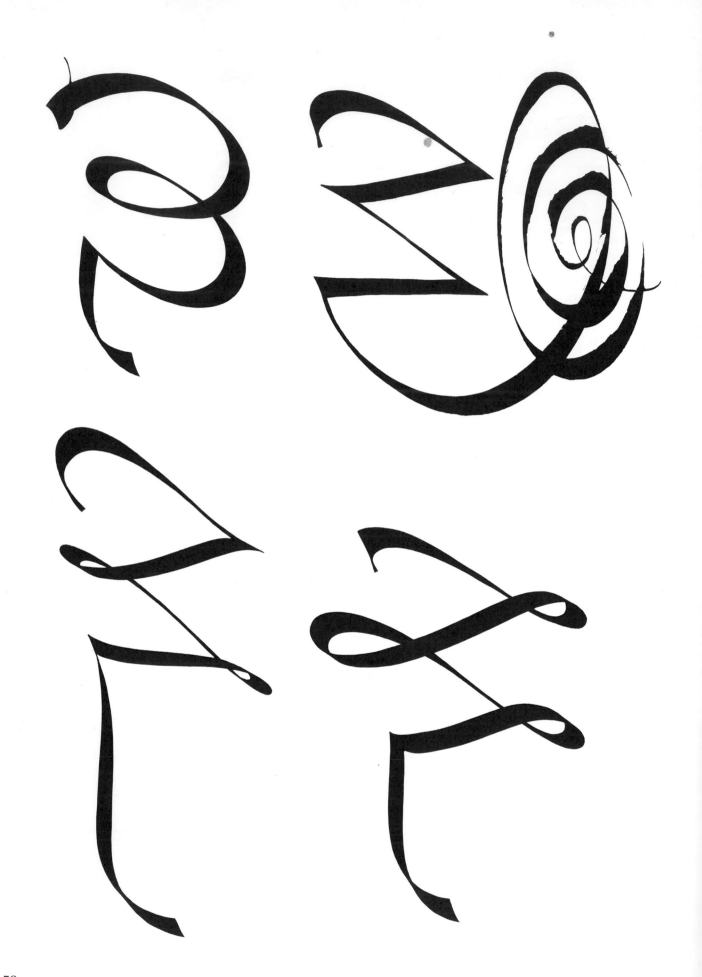

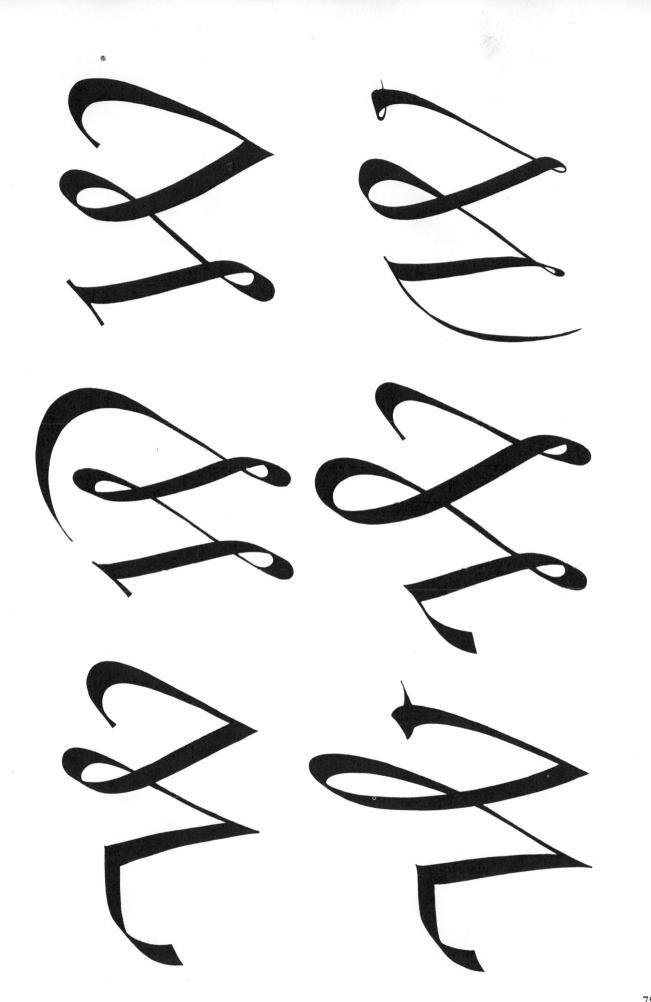

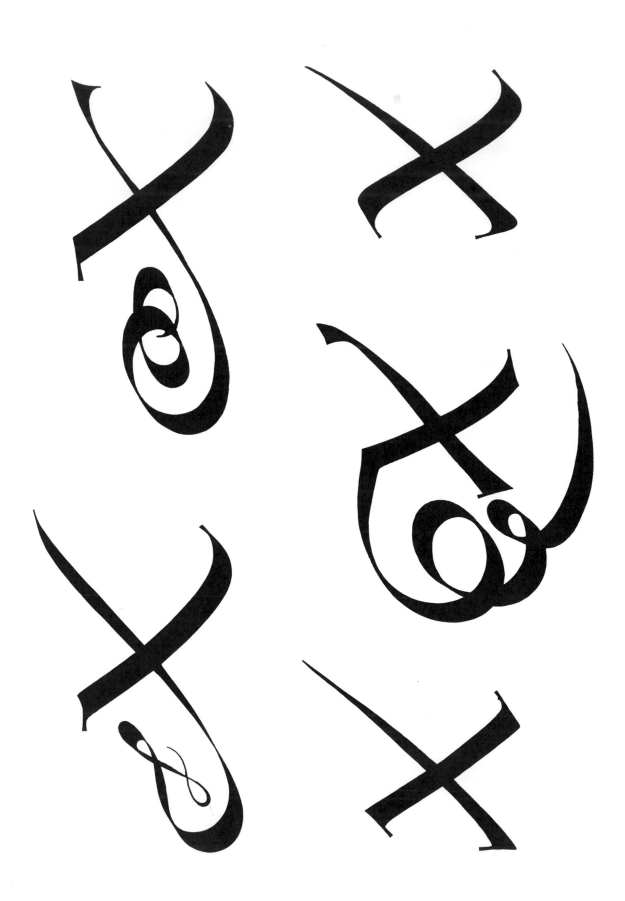

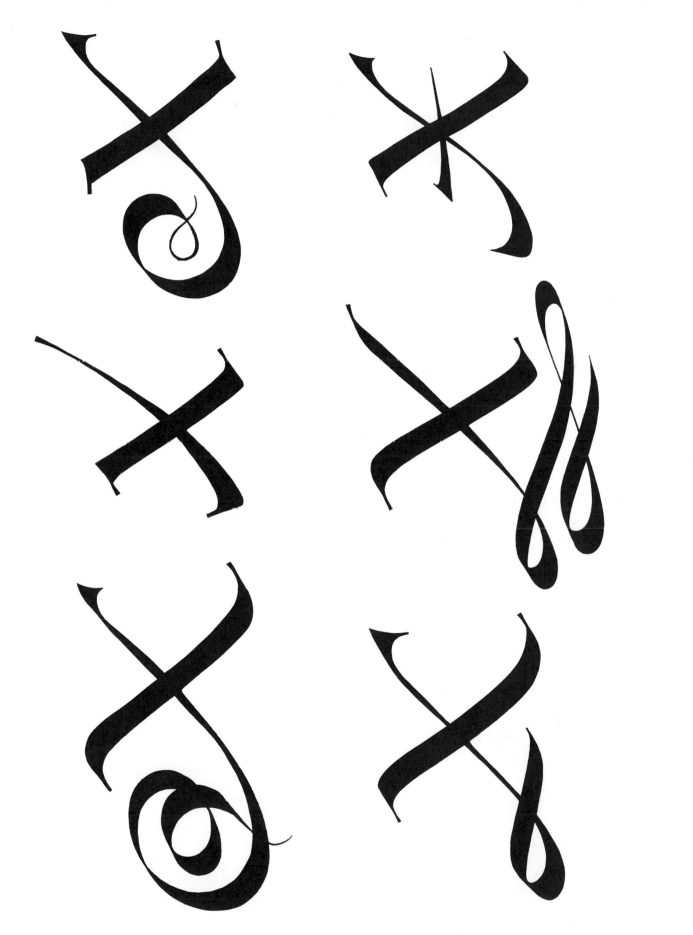

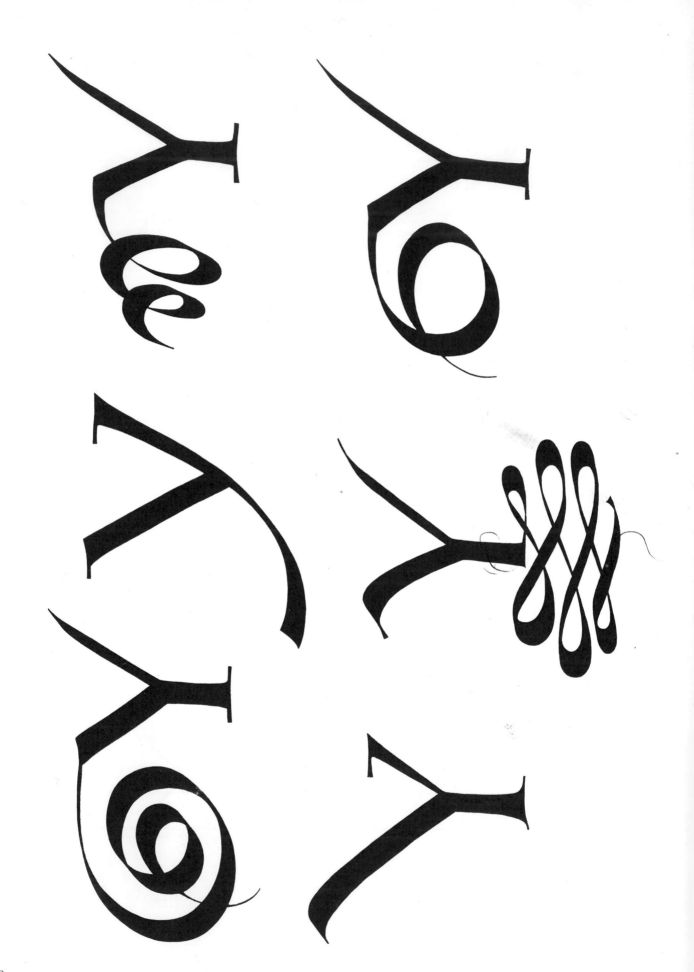

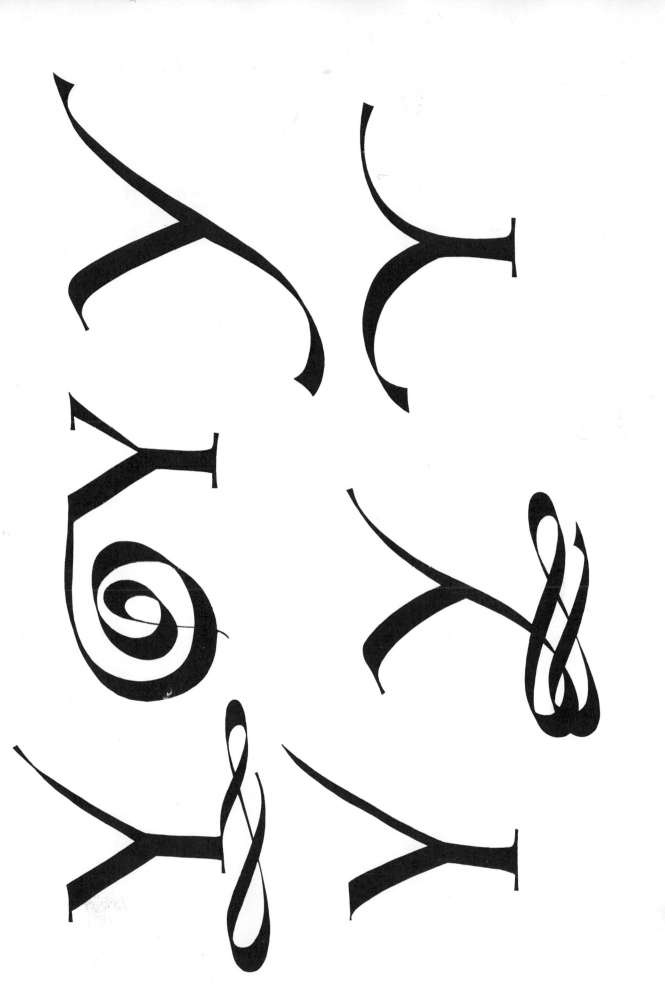

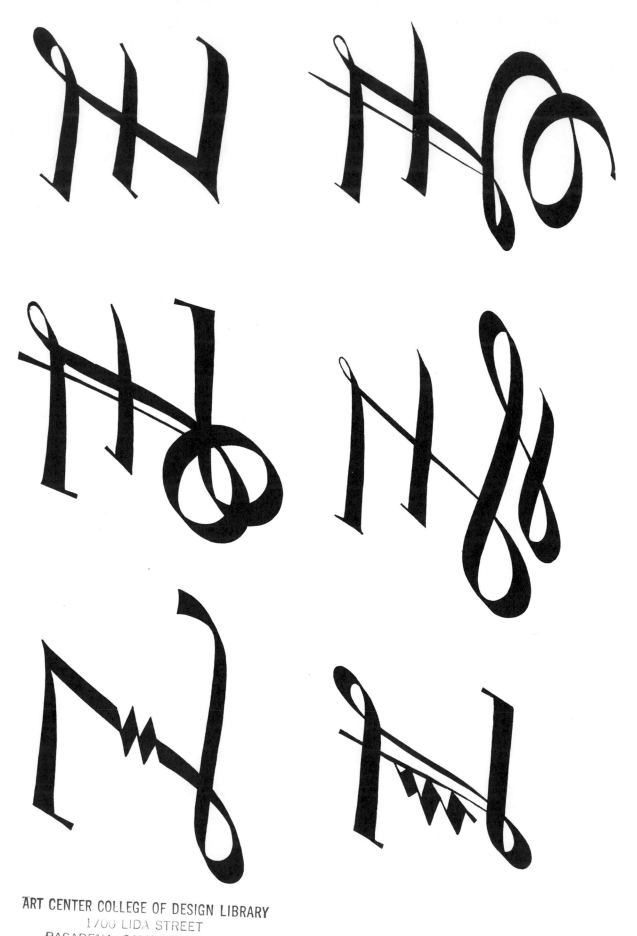

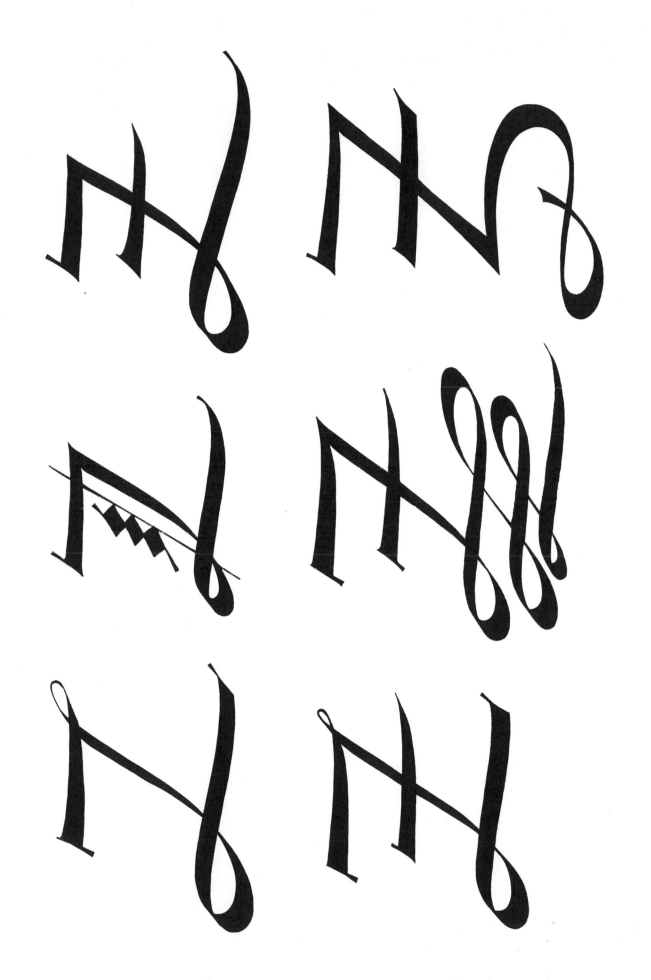

4.17.85 3.95 Dover # 27725